HOW TO READ
ART

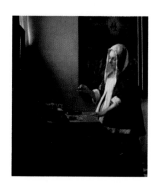

THE FUN ONE HUNDRED

#	Name	Caption
1	PABLO PICASSO	he had a lot of the above
2	MARCEL DUCHAMP	what a pisser
3	SALVADOR DALI	liked lots of cheques (+ gold)
4	M. KIPPENBERGER	good mood NAZI gas station
5	RICHARD PRINCE	you must be joking
6	RENE MAGRITTE	Ceci nest pas une blague
7	JEFF KOONS	shagging
8	PAUL McCARTHY	Santa Chocolate Schlop
9	PHILIP GUSTON	very studio (us)
10	CY TWOMBLY	scribble
11	SIGMAR POLKE	magic mushrooms
12	ED RUSCHA	burn Hollywood burn
13	G. MATTACLARK	prime cuts
14	CHRIS BURDEN	shoot to kill
15	BRUCE NAUMAN	fun from rear
16	DAVID SALLE	cavalier of the canvas
17	HENRI MATISSE	original formalist
18	J. POLLOCK	paint spill
19	RICHARD SERRA	weight watcher
20	JOHN BALDESSARI	he's making no more boring art
21	MIKE KELLEY	pant skitter and proud
22	ANDY WARHOL	Ass in hole (s)
23	W. DE KOONING	dutch courage
24	ROBERT SMITHSON	a quake in a lake
25	DUANE HANSON	white trash
26	J-M BASQUIAT	"The FUN'S over"
27	CHARLES RAY	road kill
28		that's one way of doing it...
29	V VAN GOGH	ouch! * @?
30	RAYMOND PETTIBON	geek cartoons
31	JASON RHOADES	total organised chaos
32	CINDY SHERMAN	dressing up
33	JULIAN SCHNABEL	plate rage
34	FRANK STELLA	very protracted
35	NAN GOLDIN	fancy trannies
36	CAROLL DUNHAM	cum filled junk
37	PHILIP TAAFFE	snakes and ladders
38	ROY LICHTENSTEIN	wham
39	STUART DAVIS	jazz bop
40	SOL LE WITT	interior decorator
41	VITO ACCONCI	what a tosser
42	SEAN LANDERS	'you cannot be serious'
43	FRANCIS BACON	pissed and proud
44	ALEX KATZ	party time
45	F.GONZALEZ-TORRES	candy man
46	MATTHEW BARNEY	the man who fell to earth
47	JOSEPH BEUYS	was he for real
48	PIERO MANZONI	shit happens
49	DAMIEN HIRST	silence of the lambs
50	KAREN KILIMNIK	Mrs Peel we're needed
51	DONALD JUDD	boxing clever
52	JOHN CURRIN	Renaissance man
53	CECILY BROWN	orgy-tastic
54	SUE WILLIAMS	fucked up
55	GARY HUME	stadium rock
56	LOUISE BOURGEOIS	hilarious interview style
57	BARRY LE VA	making a mess
58	JENNY SAVILLE	zombie flesh eaters
59	GENE COLOUD	see number one
60	CHRIS OFILI	shit head
61	CHRISTOPHER WOOL	American graffitti
62	FRANCISCO GOYA	Hannibal the cannibal
63	JESSICA STOCKHOLDER	assembly line
64	GUSTAV KLIMT	orna-MENTAL- as anything
65	ANTHONY CARO	not really funny !
66	GILBERT & GEORGE	smashed
67	CARL ANDRE	nice brickwork
68	CHUCK CLOSE	up close + personal
69	DIETER ROTH	trash the gaff
70	KEN NOLAND	Oin Oin Oin OinOinOinO
71	MARIKO MORI	temple of doom
72	UGO RONDINONE	sooper model wannabes
73	PIET MONDRIAN	celebrity squares
74	LAURA OWENS	feel good art
75	DAN FLAVIN	how many artists does it take to change a lightbulb?
76	TERRY WINTERS	space invader
77	ROBERT GOBER	wall paper
78	ERIC FISCHL	bad boy
79	YVES KLEIN	blue movie style
80	JORG IMMENDORFF	bar brawls
81	GLEN SEATOR	checks cashed
82	PIPILOTTI RIST	road rage
83	JAMES ROSENQUIST	stealth bomber
84	JASPER JOHNS	star spangled banner
85	ANDREAS GURSKY	Nike Town
86	DAVID HOCKNEY	pool attendant
87	ELLEN GALLAGHER	funny faces
88	RITA ACKERMANN	get a job
89	RICHARD HAMILTON	The Beatles: The Beatles
90	ASHLEY BICKERTON	beach bum
91	JULIAN OPIE	virtual reality
92	ANDRES SERRANO	pissed christ
93	PETER HALLEY	cell by date
94	TONY OURSLER	ventriloquist dummy
95	ALBERT OEHLEN	portrait of A. Hitler
96	DOUG AITKEN	Electric Earth
97	MARTIN HONERT	tourist trap
98	SARAH LUCAS	toilet humour
99	JACK PIERSON	wHat tHE fUcK
100	VANESSA BEECROFT	hanging out

HOW TO READ
ART

*A crash course in understanding &
interpreting paintings*

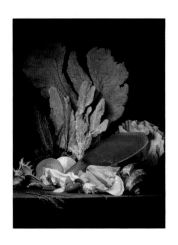

NEW YORK

New York Paris London Milan

Liz Rideal

First published in the United States
of America in 2015 by
Rizzoli International Publications, Inc.
300 Park Avenue South
New York, NY 10010
www.rizzoliusa.com

Copyright © 2014 The Ivy Press Limited

ISBN: 978-0-7893-2916-5
Second Printing, 2016
2016 2017 2018 2019
10 9 8 7 6 5 4 3 2

Library of Congress Control Number:
2014948368

Printed in China

Front cover image: *Adéle Bloch-Bauer I*
by Gustav Klimt, 1907
© Dover Images

Back cover image: *Still Life with Bowl
of Citrons* by Giovanna Garzoni, 1640s
© The J. Paul Getty Museum, Los Angeles

This book was conceived, designed
and produced by

Ivy Press

Ovest House
58 West Street, Brighton
BN1 2RA, UK
www.quartoknows.com

CREATIVE DIRECTOR Peter Bridgewater
PUBLISHER Susan Kelly
EDITORIAL DIRECTOR Tom Kitch
ART DIRECTOR Michael Whitehead
EDITOR Jamie Pumfrey
DESIGN JC Lanaway

Contents

While many paintings can be appreciated quite simply for what they are, our enjoyment of them can be enhanced by honing our looking skills. Artists make paintings because they feel compelled to. They are inspired to create analogies with the world that surrounds us; to interpret emotion, scenarios, and life using

paint. A variety of works are gathered here specifically for us to examine in depth, and to learn how to understand the meanings behind the paintings and the stories that they tell. It isn't, nor does it aim to be, an all-encompassing history of art—its aim is more modest, instead inviting you to develop your understanding and knowledge of art.

Oil on canvas or wood is the mainstay of our investigation, and we start with a comparison of two beautiful women, both residents of the Louvre—originally a private royal palace, transformed in 1793 into the world's first public art gallery. Leonardo's Mona Lisa and Marie-Guillemine Benoist's unknown woman are both enigmatic; each represents a moment in history. Swathed in draperies that flatter their bodies, they

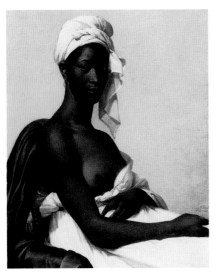

◀ **Portrait of a Black Woman**,
Marie-Guillemine Benoist, *1800,
oil on canvas, 25 1/2 x 32 in. (65 x
81 cm), Louvre, Paris.*

appear calm, self-sufficient, and composed, their hands in repose. One is the most visited and acclaimed painting in the gallery, while the other sits in a quiet corner on the opposite side of the palace. Benoist's portrait celebrates the abolition of slavery in the colonies, despite her subject's naked breast, which could suggest a continuation of another kind of bondage. Leonardo's is a potential marriage portrait that never left his studio. Both paintings are mysterious, and this is why they continue to intrigue us.

Art is a visual language, not one of words, and so conclusions about artworks based on verbal or written communication are a parallel but not a true equivalent. However, discussing painting helps us to empathize, to enjoy the image, and to learn more about the process of creating it.

Painting may be static, but it is still exploding in other ways. Today our

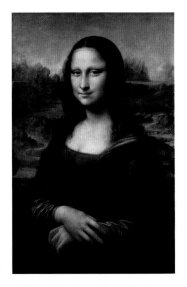

▲ **Mona Lisa**, Leonardo da Vinci, c.1503–19, oil on wood, 30⅓ x 21 in. (77 x 53 cm), Louvre, Paris.

understanding of the visual world around us—advertisements, moving images, and computer graphics—confirms that our society can conduct sophisticated "readings" that can extend to painting, too.

7

Introduction

This unlikely juxtaposition of paintings gives us an insight into people's attitudes towards collecting art. Johann Zoffany's eighteenth-century painting, commissioned by Queen Charlotte, shows the special hexagonal room in the Uffizi Palace in Florence, which contained masterpieces of the Medici Collection belonging to the Grand Duke of Tuscany. Within it we see the way that these Renaissance works are hung salon style—in serried ranks, covering the walls—and the visiting Grand Tourists, who are discussing the highlights. Zoffany is so meticulous that we can identify paintings by Raphael, Holbein, and Rubens, and even recognize which grandees are discussing what artworks. This painting speaks to us about the variety of artistic styles and subject matter.

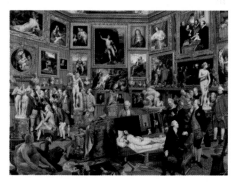

▲ **The Tribuna of the Uffizi**, Johann Zoffany, 1772–7, oil on canvas, 48½ x 61 in. (123.5 x 155 cm), Royal Collection, London.

In stark contrast, Peter Davies's painting is in shopping-list format, to which he has added personal opinions by means of cryptic comments. Conveniently for us, he broadens the scope of this book in one fell swoop. This type of text painting invites us to make assumptions about Davies's taste in the same way that Queen Charlotte would have been able to make assumptions about the artistic tastes of the Grand Duke. Both collections offer different ways to examine the groupings of paintings, an idea studied in the composition of this book.

A work by American artist John Baldessari, *What is Painting* (1966–8), consists of a sign-painted text, ART IS A CREATION FOR THE EYE AND CAN ONLY BE HINTED AT WITH WORDS. Conceptual artist Marcel Duchamp argued that the existence of an artwork depends on both the artist and the spectator. Western art is a language you can recognize but perhaps not fully understand until you are familiar with its specializations and methods. Time will decide whether a work is an investment masterpiece or simply a painting by an unknown artist. The beauty of art is in the eye of the beholder, but thinking about art and looking at it is often free, and can be deeply satisfying and rewarding.

Taste is subjective, and art preference is all about taste. However, first you need to understand the criteria for making judgments. Everyone can say, "I know what I like," but do you really? And how do you know? What informs your judgment? Is it prejudice or memory, feeling or education? Perhaps this book will expand your mind's eye with intellectual problems and delights, and, in some instances, conclusions.

▼ **The Fun One Hundred (Pink Top Version)**, Peter Davies, 2000, acrylic on canvas, 72 x 48 in. (183 x 122 cm), British Council Collection.

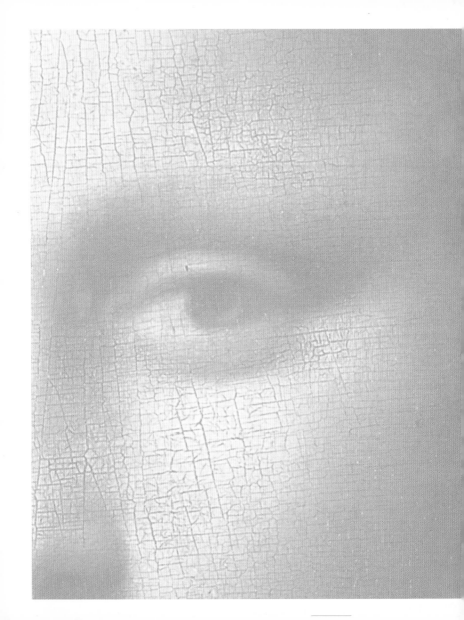

GRAMMAR OF PAINTINGS

In this section, the five main aspects of painting are considered: shape and support, medium and materials, composition, style and technique, and signs and symbols. Looked at in the context of the artists' work, these are key to a greater understanding and enjoyment of painting.

Shape & Support

Artists paint on all manner of surfaces, called supports, and at different periods there have been fashions for different-shaped paintings. In the main, however, the standard formats remain—the vertical portrait, the horizontal landscape, and, less frequently, the oval and the circle. Subject matter, the initial reason for the painting, determines the shape and thus the composition.

Supports can be wood, canvas, or linen pulled taut over stretchers (originally made of wood but now usually metal). They can also be ceilings or walls. In the very beginning, supports were the walls of caves. What you paint on defines to a certain extent the result that you can achieve.

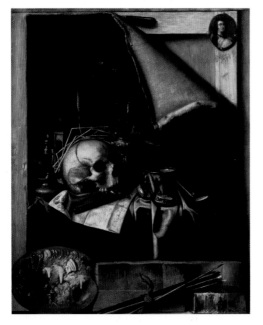

◀ **Vanitas**, Cornelius Gysbrechts, *1664, oil on canvas, 34½ x 27¾ in. (87.3 x 70.5 cm), Ferens Art Gallery, Hull.* A master of trompe l'oeil, Gysbrechts had fun here illustrating studio paraphernalia, indicating the physicality of painting by showing dripping paint and the ripped surface of the canvas, then revealing its stained underside, the stretcher bar, and a miniature.

► **The Arts and Sciences: Painting and Sculpture**, François Boucher, *1750–2, oil on canvas, 85½ x 30½ in. (217.2 x 77.5 cm), Frick Collection, New York.* Softly sensual art featuring blond putti and pastel-shaded scumbled paintwork was fashionable in eighteenth-century France. Art critic and philosopher Diderot's artistic classifications of sculpture and painting are manifested in this, one of

▲ **Self-portrait with Endymion Porter**, Anthony Van Dyck, *c.1635, oil on canvas, 43⅓ x 45 in. (110 x 114 cm), Prado Museum, Madrid.* This self-portrait cleverly turns the oval on its side, making room for two subjects. Further complementing Porter, his friend and patron, Van Dyck uses white to bring him forward within the design, in contrast to the recessive black tones and contrapposto pose he has used for his own portrait.

a series of decorated internal panels, by tools of the trade, as both artforms gradually gained territory within the work hierarchy, moving up from mere craft to the realm of gentlemanly pursuit.

► **Portrait of a Young Man**, Nicholas Hilliard, *1588, vellum laid on card, 1⅝ x 1⅜ in. (40 x 33 mm), Metropolitan Museum of Art, New York.* Miniatures were worn around the neck or on hatbands as badges of loyalty or signs of devotion. Hilliard trained as a jeweller, and he used real gold and silver for decoration. The lace collar is painted thickly, standing proud of the surface. Old playing cards were recycled for this art, which was known as "limning."

► **The Miracle of the Holy House of Loreto**, Giovanni Battista Tiepolo, *oil on canvas, 48⅜ x 30⅜ in. (123 x 77.2 cm), J. Paul Getty Museum, Los Angeles.* This study is all that remains of the ceiling fresco for the Scalzi church in Venice. The oval reveals the tripartite structure of

the story, using the technique *di sotto in sù*, literally "from below upwards." The scene expands heavenward, showing earthly sinners, through saints and angels, to God and the Holy Ghost.

Shape & Support

The art world changed dramatically in the twentieth century, and religious painters such as Matthias Grünewald became redundant. Artists wanted to explore what they could do with the picture plane itself. How could they subvert the age-old tradition of canvas? They set about piercing it and shaping it, used other types of surface on which to paint, and made this the subject of their art. These works were destined for the "white cube," a blank space where they could be viewed in a privileged position without the interference of church or state. The idea is that they are autonomous.

▲ **Morning Choice**, Anne Truitt, *1968, acrylic on marine plywood, 72 x 14 x 14 in. (182.9 x 35.6 x 35.6 cm), St Louis Art Museum.* This support is the structure, surface, and meaning all in one. The complex work hovers between painting and sculpture, minimal and elegant, with joyously evocative colors. Truitt also wrote books about the artistic life and how it can be led, including *Daybook* and *Prospect*.

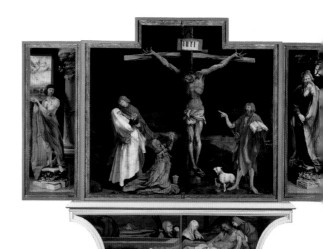

▶ Empress of India,
Frank Stella, *1965, metallic powder in emulsion paint on canvas, 77 x 216 in. (195.6 x 548.6 cm), Museum of Modern Art, New York.*
Stella pushes the boundaries of formulaic painting rules by making the support integral to the structure of the painting itself. The stretcher bars are the same width as the painted lines. The thin unpainted lines are revealed by the thicker colored sections.
Pencil lines show the compositional mapping.

◀ Isenheim Altarpiece,
Matthias Grünewald, *1512–16, oil on wood, 135⁴/₅ x 198⁴/₅ in. (345 x 482 cm), Unterlinden Museum, Colmar.*
Convenient for moving, smaller wooden triptychs could be easily opened and closed for display. The wings of this altarpiece were opened on specific religious occasions, revealing different aspects of the story. St Sebastian and St Anthony both symbolize protection from disease. We can compare the lower Christ with that by Mantegna (*see p21*).

▶ Four Colour Frame Painting, No. 4, Robert Mangold, *1984, acrylic and black pencil on canvas, 120 x 84 in. (304.8 x 213.4 cm), The Nelson-Atkins Museum of Art, Kansas City.*
Mangold lays bare the idea of a regular frame, and conjures a complex layout of mathematical connections. His work is characterized by the celebration of the oval in relation to the rectangle, and of the part that color can play in connecting a three-dimensional story within two dimensions.

◀ Spatial Concept,
Lucio Fontana, *1960, slashed canvas and gauze, 36³/₅ x 28²/₃ in. (93 x 73 cm), Museum of Modern Art, New York.*
Attacking the illusion of painting, the aggressive slit is literally clear-cut, forcing us to consider the nature of the linen, its color and its texture, and the bow of material under stress. We look again and wonder how the artist had the nerve to slash like that, to destroy in order to create.

Medium & Materials

GRAMMAR OF PAINTINGS

▼ **Still Life with Bowl of Citrons**, Giovanna Garzoni, *1640s, tempera on vellum, 11 x 14 in. (27.6 x 35.6 cm), J. Paul Getty Museum, Los Angeles.* 'Tempera on vellum' is the use of prepared animal skin as a support, and egg yolk as a binder for the applied color. The fresh egg yolk sac was pierced, and its gummy content held the pigment together. A skilled tempera artist works the quick-drying paint in multiple, sequential layers from light shades to dark ones.

Paint initially consisted of earth-colored pigments and minerals, ground by hand and suspended in oil or egg medium. Flemish painters introduced oil paint to the Italians in the fifteenth century and it superseded their traditional egg tempera paint, as it made greater depth and detail possible. Artists either mixed their own paint or bought it, stored in pigs' bladders, from professional colormen. The mechanized hand mill and the collapsible metal tube became available in the nineteenth century. These developments allowed artists to leave their studios and create their work *en plein air*, and thus spawned the Impressionist movement.

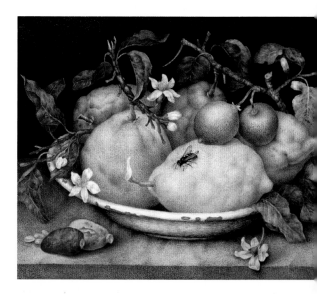

► Number 27, 1950,
Jackson Pollock, 1950,
*oil, enamel, and aluminium
paint on canvas, 49 x 106 in.
(124.5 × 269.2 cm), Whitney
Museum of American Art,
New York.*

While performing a
trance-like dance, Pollock
dripped ordinary enamel
house paints onto canvas laid on
the ground. The paint dried to form a
variety of shiny, crusty, dimpled surfaces.
The rhythmic spins and swirling chaotic
blobs and splats morphed in and out of
his invented cosmos, creating his own
personal Milky Way.

▼ Beauty with a Masked Gaze, Jean
Dubuffet, *1953, collage with butterfly wings,
9⅘ x 7 in. (25 x 18 cm), Hamburg Kunsthalle.*
A champion of *art brut*—literally "raw art,"
made by untrained artists—Dubuffet
encouraged viewers to use their
imagination to interpret his pictures.
He was prone to incorporating sand and
other unconventional materials in his
work to convey his individual vision.
Here, collaged butterfly wings symbolizing
fragile beauty supplant paint to create a
surrealistic figure.

▲ Achrome, Piero Manzoni, *c.1960,
kaolin on canvas, 7 x 9⅗ in. (18.1 x 24.3 cm),
Museum of Modern Art, New York.*
Interested in the dichotomy between
human production and art production,
Manzoni became notorious as the artist
who canned his own excrement. In
contrast, the *Achromes* appear low key
and conventional, questioning texture,
light, and scale, but their materials—dried
china-clay on canvas—are not. These
carefully pleated blank bandages assert
a new kind of painting process.

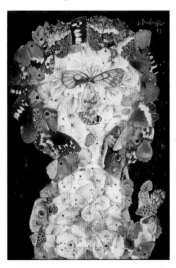

Medium & Materials

New stable, synthetic colors were developed chemically during the nineteenth century. For example, French ultramarine overtook naturally occurring, expensive lapis lazuli. Oil paints require solvents such as turpentine and mineral spirits for dilution. Varnishing is traditional as a final coating on dried paint to add a glossy sheen. Water-soluble acrylic emulsions were marketed in the 1960s and made fashionable by David Hockney. Their accompanying acrylic medium can be used both as a mixer and a stable glue. The advantage of acrylic is that it dries quickly, but it lacks the depth achievable with slow-drying layers of translucent oil glazes.

◀ **Orange and Yellow**, Mark Rothko, 1956, *oil on canvas, 91 x 71 in. (231.1 x 180.3 cm), Albright-Knox Art Gallery, Buffalo.* Rothko's idiosyncratic technique included the complex layering of diluted paints. Light filters through these aqueous, chromatic layers with their edges gently furred, fudged, and blurred. Close up the color melds and fuses, while further away the distinctive bands of hue seem to hover and float in a trembling, otherworldly haze.

▶ **Green Pool with Diving Board and Shadow**, David Hockney, *1978, colored and pressed paper pulp, 50⅕ x 32⅖ in. (127.6 x 82.2 cm), Collection The David Hockney Foundation.*

Hockney combines paper pulp with pigment to make the picture piecemeal, a synthesis of form and content. The fact that many people are familiar with his previous pool paintings means our eyes are preprogrammed to interpret easily the wobbly diving-board shadow—despite the naturally unwieldy and fuzzy quality of the pulp as a material.

▲ **Lot's Wife**, Anselm Kiefer, *1989, mixed media on canvas, 137⅘ x 161⅖ in. (350 x 410 cm), Cleveland Museum of Art.*

Kiefer's wretched landscape is imbued with grief, the railway line perspective evoking the misery of Auschwitz-Birkenau. He conflates this with the Old Testament story of a disobedient woman turned into a pillar of salt. Crumpled and puckered, the dull finish of the materials, ranging from ash and salt to copper and lead, echo the barren scene.

▼ **Fallen Painting**, Lynda Benglis, *1968, pigmented latex, 355 x 69¼ in. (901.7 × 175.9 cm), Albright-Knox Art Gallery, New York.*

Benglis has an affinity with difficult materials and is adept at corralling them into subverting the picture plane. Here, the enigmatically titled *Fallen Painting* appears like a huge snail trail of color-muddled plasticine. Its scale challenges the viewer— it is unexpected, rubbery, and steadfastly difficult to categorize—as it proudly defies traditional painting.

Composition

The golden ratio, mean, or section is also known as the divine proportion. It is a mathematical formula underpinning the elements within an artwork, making it look aesthetically balanced. The visually satisfying structure can be populated by figures, props, perspective, color, tonal range, and atmosphere. Painters construct the compositional spaces that we perceive, and some filmmakers base their films on this technical expertise, copying the mood and style of painted compositions—for example, Hitchcock's dramatic use of lighting recalls Caravaggio, and dream sequences have been inspired by the surreal worlds of Dalí and Magritte. The word "composition" applies to music, too, and when analyzing art, it can be useful to think about how art is created in relation to music.

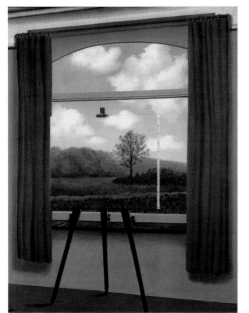

◀ **La Condition Humaine**,
René Magritte, *1933, oil on canvas, 39²⁄₅ x 32 in. (100 x 81 cm), National Gallery of Art, Washington, DC.*
Magritte presents ordinary objects in impossible contexts. He challenges us to consider our place in relation to the world; our own humanity. An arched window frames the mundane landscape outside; the pulled curtain is a stagy adjunct to this "ordinary" scenario.

▶ Scotland Forever,
Lady Elizabeth Butler, *1881,*
oil on canvas, 40 x 76½ in.
(101.6 x 194.3 cm),
Leeds Art Gallery.
Butler exploits the suspension
of disbelief called for when we
enter into the "depth" of a flat
canvas. The white horses with
their red-clad riders thunder
toward us with terrifying
speed under a sky bright with

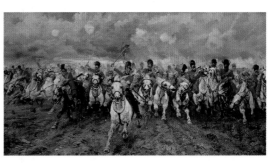

sparks of musket fire. The foreshortening the
artist has used within the picture plane is
extreme and effective.

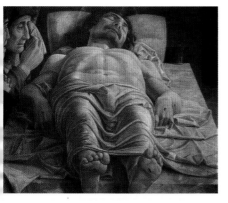

▲ The Lamentation of Christ, Andrea
Mantegna, *c.1480, tempera on canvas, 26⁴/5 x*
32 in. (68 x 81 cm), Pinacoteca di Brera, Milan.
This abrupt, arrestingly avant-garde view
is still shocking: Christ on the slab, like
a piece of dead meat. His body fills the
space so that we hardly notice the
weeping mourners to the side. His pallor is
terrifying, and the winding sheet confirms
the emotional despair and reality of death.

▼ The Conversion of Saint Paul,
Caravaggio, *1601, oil on canvas, 90⅔ x 69 in.*
(230 x 175 cm), Santa Maria del Popolo, Rome.
Although commissioned for a church,
Caravaggio's clever work was deemed
inappropriately realistic because of the
way he sucks us into the action and
highlights the drama within the dark space.
The body of the horse frames the moment
of action, as St Paul is struck by light and
knowledge simultaneously.

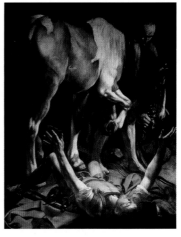

Composition

▼ The Studio (Vase before a Window), Georges Braque, *1939, oil with sand on canvas, 44½ x 57½ in. (113 x 146 cm), Metropolitan Museum of Art, New York.*

The triptych of vertical windows with their view of clouds dominates this complex picture. Everything unfolds in the surrounding space, but the windows provide the point of rest and respite. The riot of pattern, controlled by demarcated white borders, carves up this multi-textured composition of wood effects and domesticity.

Artists use reliable devices to anchor their compositions, such as the window frame that also signifies our view of the world, or easily recognized demarcations between foreground, middle, and background. However, their views are constructed rather than simply copied. Isolated elements are coaxed into convergence in order to create an aesthetic composition that may include dynamic perspectives. Patterned surfaces are used to suggest movement and a variety of color and tonal range lends atmosphere. An experienced artist can recycle formulaic signature compositions, but these may not always include the magic ingredient that will elevate the work to masterpiece quality in the eyes of the viewer.

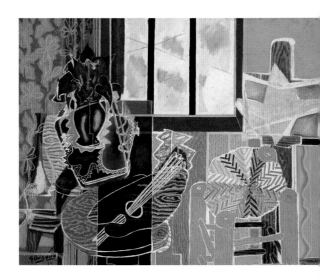

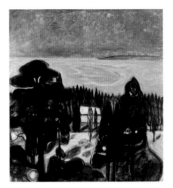

▲ **A White Night**, Edvard Munch, *1901, oil on canvas, 45½ x 43½ in. (115.5 x 110.5 cm), National Gallery, Oslo.* Munch described nature as being like a "picture on the back of the eye." This silent moonlit scene evokes that internal landscape. Serried ranks of evergreen pine split the square canvas, black and white working in tandem to create a syncopation that lifts the melancholy of the northern stillness.

▼ **The Arnolfini Portrait**, Jan van Eyck, *1434, oil on wood, 32⅖ x 23⅔ in. (82.2 × 60 cm), National Gallery, London.* As well as his wealthy Italian clients, the artist records himself, reflected in the mirror. The painting bristles with detailed information. Despite appearances, the woman is not pregnant but fashionably dressed in heavy swathes of green material; he wears fur, the dog represents loyalty, and the interior is chic. All the elements fuse within the expensive, claustrophobic space.

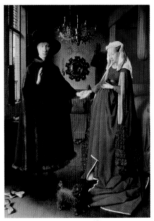

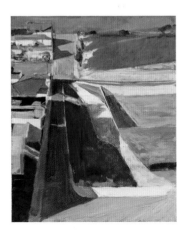

◄ **Cityscape**, Richard Diebenkorn, *1963, oil on canvas, 60⅕ x 50½ in. (153 cm x 128.3 cm), San Francisco Museum of Modern Art.* Diebenkorn flew over the southwestern United States and used the experience to inform the abstract viewpoints of his painting. The bright light and sharp shadows enhance the elevated quality. Spots of distinct colour—red, yellow, and turquoise blue—enliven the flatness of the surface.

Style & Technique

Refining a technique of painting can create a signature style that is recognizable. An artist can achieve this by manipulating the various properties that formulate an artwork: the harmonies of light, line, color, and space. Surface can reveal texture and highlight volume, creating contours. Colors can be warm or cool, combined together to create flesh tones or suggest mood. Space can be shallow and cramped, or deep and vast. Technical special effects are often identified with historical periods, such as the translucent dew drops that are widely used in Dutch still-life paintings of the seventeenth century. Specific words such as *scumble* and *impasto* describe particular painterly effects.

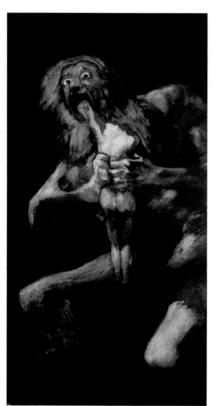

◀ **Saturn Devouring One of His Sons**, Francisco Goya, *1821–3, oil mural, transferred to canvas, 56½ x 32 in. (143.5 x 81.4 cm), Prado Museum, Madrid.* The chiaroscuro effect here is symbolic, as Saturn devours his child against a dramatic, hellish black background. Goya's technique embraces shock tactics and we are transfixed in horror by the mad terror of the act, reflected in Saturn's staring saucer eyes. Blood red completes the tight rectangle of the picture.

City Night, Georgia O'Keeffe, *1926,
oil on canvas, 48 x 30 in. (121.9 x 76.2 cm),
Minneapolis Institute of Arts.*
Known for her succulent, ambiguously rendered plant forms, O'Keeffe's "skyscraper-scape" relates strongly to Modernist photography. The bold, sparse uprights, reinforced by the portrait-shaped canvas, present a condensed view of the city. The buildings seem as assured as her composition—vertical, solid, and confident.

▶ **Study of a Model (for The Raft of the Medusa)**, Théodore Géricault, *1818–19,
oil on canvas, 18²⁄₅ x 15 in. (46.7 x 38 cm),
J. Paul Getty Museum, Los Angeles.*
Painted sketches can possess more zest than a final work, seemingly imbued with concerted hand-eye coordination and extra focus. The eyes are alive and expressive, the rendered skin has a pearly sheen; blue and chocolate brown mix with tints of white to create a modulated and convincing surface.

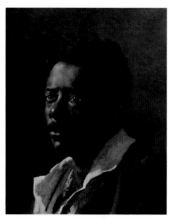

◀ **Small Pleasures**, Wassily Kandinsky, *1913,
oil on canvas, 43¹⁄₃ x 47¹⁄₂ in. (110 x 120.6 cm),
Guggenheim Museum, New York.*
Wagner's deconstruction of the sonata structure influenced Kandinsky, whose painterly equivalent was swirling patches of energetic color—here refined, there with added blobs of contrasting paint, suggesting the vibrations of orchestral sounds. Tints heighten aspects of the compositional flurry, contrasting with the pure black employed as vivid calligraphic line.

Style & Technique

Style and technique combine to create what we understand as an artist's trademark and context, and also influence the way we see. The Impressionists seem tame today but in their time caused uproar with their now-familiar brightly colored and loosely painted canvases. Famously referred to as the artist who created "the camembert of time" with his bendy rubber watches, Dalí was his own living, walking brand before Andy Warhol even thought of such a thing, painting astonishing scenarios where every nook and cranny leads us into other dimensions, forms, stories, and characters. Francis Bacon concentrated on the figure within delineated frameworks, creating a structure as recognizable as Mondrian's colored geometric abstractions.

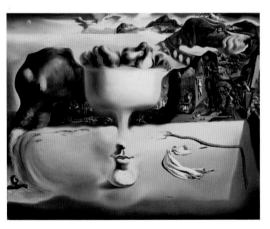

◀ **Apparition of Face and Fruit Dish on a Beach**, Salvador Dalí, *1939, oil on canvas, 45⅕ x 56⅔ in. (114.8 cm x 143.8 cm), Wadsworth Atheneum, Hartford.* Dalí's ability to paint in an exact likeness of reality seduces and transfixes the viewer with wonder and admiration. A flamboyant figure, he epitomizes the artist as magician, using formal, traditional compositions to relay the fantastical, the nonsensical, and the bizarre, with spacey colors and preposterous details.

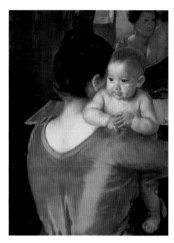

▲ **Woman in a Red Bodice and her Child**,
Mary Cassatt, *c.1901, oil on canvas,
27 x 20⅕ in. (68.6 x 51.4 cm), Brooklyn
Museum of Art, New York.*
This unusual viewpoint creates an
opportunity for the child to take center stage
while its relationship with the mother retains
our focus. The red-orange blouse engulfs the
lower part of the painting and grabs our
attention—a ploy to hold the eye and direct
our gaze further, into the mirror and beyond.

▶ **Study from the Human Body**,
Francis Bacon, *1949, oil on canvas,
58 x 130⅔ in. (147.2 x 130.6 cm),
National Gallery of Victoria, Melbourne.*
Dragging dry paint onto plain linen suggests
transparent curtains. Bacon manipulates
our imagination: Is this a showering or a
departing figure? The buttocks and ear are
clearly defined. Black shadowing above the
head contrasts with the impastoed white
right arm, fixing our focus.

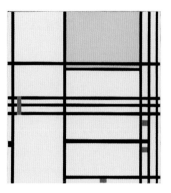

▲ **Painting Number 9**, Piet Mondrian,
*between 1939 and 1942, oil on canvas,
31⅖ x 29⅓ in. (79.7 x 74.3 cm),
The Phillips Collection, Washington, DC.*
Mondrian's style typically employs a trinity
of primary colors divided by black bars.
The strict composition coupled with the
variety of sizes of the component parts imbue
these works with individual character. The
artist juggles the spaces, balancing them to
suggest rhythm and tension.

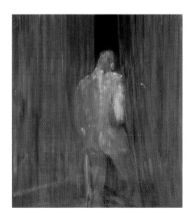

Signs & Symbols

Signs in painting can be straightforward or ambiguous; include a curtain in a painting, for example, and it may signal a variety of things—intrigue, wealth, a performance—or it may be a simple excuse for an artistic display of brushwork exploring space and color. Similarly, a heart or a red rose depicted in a painting might suggest love today, but at other periods they may have held other meanings. Cesare Ripa published his illustrated *Iconologia*, a code book to symbols and emblems, in 1603, and it was used widely by artists, Johannes Vermeer among them.

NON SINE SOLE
IRIS

◀ **Elizabeth I: the Rainbow Portrait**, Isaac Oliver, c.1600–02, oil on canvas, 50 x 39 in. (127 × 99.1 cm), Hatfield House, Hertfordshire.

The rainbow clutched by Elizabeth I suggests that she has power over the heavens. The Latin inscription reads "No rainbow without sun," implying that she is the almighty sun. Her sleeve is decorated with a serpent of wisdom, while the disembodied eyes and ears ornamenting her sunburst-colored dress symbolize her aural and visual powers.

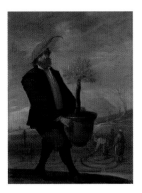

▲ **The Four Seasons: Spring**, David Teniers the Younger, *c.1644, oil on copper, 8³/₄ x 6¹/₂ in. (22.1 x 16.5 cm), National Gallery, London.*
One of the four seasons representing the cyclical wheel of time, Spring is announced by a robust gardener in red cap and jerkin bringing out a heavy terra-cotta pot. His colleagues ready the earth for the healthy green-topped plant, which serves as a phallic symbol of fertility and renewal.

▼ **Portrait of a Lady with a Dog**, Lavinia Fontana, c.1580, *oil on panel, 38¹/₅ x 28¹/₂ in. (97.1 x 72.4 cm), Auckland Art Gallery Toi O Tamaki, New Zealand.*
Fontana came from an artistic family and was also a talented musician. This portrait focuses on wealth and status as conveyed by clothing resplendent with jewels and embroidery. The tiny dog is a symbol of fidelity. Her clothes and its white and tawny coat match, making it appear to be an extension of her form, the dark shiny eyes echoing the beads around her neck.

◀ **T. S. Eliot**, Patrick Heron, *1948, oil on canvas, 30 x 24⁴/₅ in. (76.2 x 62.9 cm), National Portrait Gallery, London.*
Inspired by Georges Braque's Cubist experiments, this portrait combines profile, full face, and abstraction. Although it celebrates abstract ideas, if we look carefully at Eliot's right shoulder we can see the fluid outline of a cat. It was painted the year after Eliot won the Nobel prize for literature.

Signs & Symbols

▼ **Landscape with Psyche outside the Palace of Cupid ("The Enchanted Castle")**, Claude Lorrain, *1664, oil on canvas, 34¹⁄₃ x 59²⁄₅ in. (87 x 151 cm), National Gallery, London.* Psyche's dilemma is expressed by her languishing pose. Claude conjures a pearly sheen on the dreamy, idyllic scene. In the story, Psyche's fate is uncertain: If she peeks at her lover as he sleeps, she is ruined.

Vanitas paintings that exhort moral behaviour during our fleeting presence on earth were inspired by the Latin text, *Vanitas vanitatum ... et omnia vanitas* ("Vanity of vanities, all is vanity"). Fashions in art change, and meanings are lost, but some symbols—a skull to represent death, for example—are still used, and need no translation.

In the 1960s, the writings of Erwin Panofsky revealed the forgotten layers of meaning that exist in art, while in 1974, James Hall compiled a dictionary unraveling the stories behind artistic subjects and symbols. Among them were the story of Cupid and Psyche from Apuleius's *Metamorphoses*, in turn the inspiration for Ovid's stories, which duly inspired Claude's painting, below.

▲ **Astonishment of the Mask Wouse**, James Ensor, *1889, oil on canvas, 43 x 51⅘ in. (109 x 131.5 cm), Royal Museum of Fine Arts, Antwerp.*
Inspired by the work of Hieronymous Bosch, Ensor in turn inspired the Expressionists. Here, the mysterious Wouse seems an interloper on a stage strewn with vanitas goods.

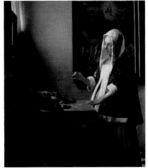

▲ **Woman Holding a Balance**, Johannes Vermeer, *c. 1664, oil on canvas, 16¾ x 15 in. (42.5 cm × 38 cm), National Gallery of Art, Washington, DC.*
A painting full of unanswered questions: the scales are balanced, yet the woman steadies herself, holding the table: is her life in balance? A dash of carmine draws attention to her belly: is she pregnant? She is bathed in light, while the painting behind her describes the resurrection and apotheosis of Christ, hinting at salvation through religion.

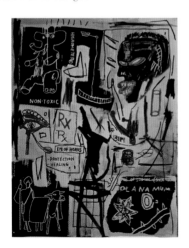

◄ **Melting Point of Ice**, Jean-Michel Basquiat, *1984, acrylic and silkscreen on canvas, 86 x 68 in. (218.5 x 172.5 cm), The Broad Art Foundation, Santa Monica.*
Basquiat's energetic, graffiti-inspired paintings combine clashing and diverse ideas into painted collages with a rippling effect. The African mask-like grinning skull reinvents aspects of vanitas paintings, while the artist also includes the protective Egyptian eye of Horus and the symbolically ambiguous seated elephant.

Signs & Symbols

If we look carefully at paintings we can often work out what is going on—the upturned tankard in the Judith Leyster painting, for example, is clear enough—but books can help us to decode them. The useful Wither's *Emblemes* is flagged by Edward Collier, who has included it in his work. Dark, claustrophobic interiors may focus attention on important symbols. Color symbolism or coding is interpreted variously by different cultures: white often stands for purity—Elizabeth I, "the Virgin Queen," was often depicted in white—but can also be associated with mourning; green suggests envy but equally hope; and red can convey danger but in China signifies happiness.

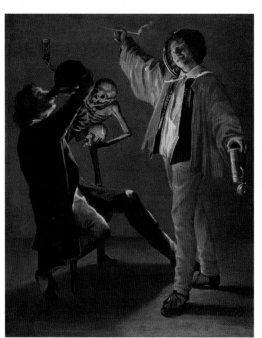

◀ **The Last Drop (The Gay Cavalier)**, Judith Leyster, *c.1639, oil on canvas, 35 x 29 in. (89.1 x 73.5 cm), Philadelphia Museum of Art.* Leyster's jolly yet moral tale is one of tipsy revellers who may be binge-drinking before the start of Lent. A skeleton with an empty hourglass and a guttering candle indicate that time is running out. Brightly illuminated and throwing sharp shadows, the subjects are caught as if on camera, smoking, drinking, and laughing.

Elements of Art: Colour, Angelica Kauffman, *1778–80, oil on canvas, 29 x 59 in. (130 x 150 cm), Royal Academy of Arts, London.* One of a set of four personifications relating to the art theories of Sir Joshua Reynolds, the figure holds a rainbow representing color and celebrating light itself, which enables us to see. The elegant arc of the bow and the curve of the palette echo the shape of the painting, as Colour sweeps through the air, stealing pigment to make art. A chameleon perches at her feet.

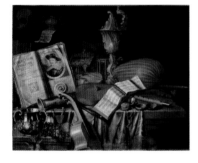

▲ **Still Life with a Volume of Wither's 'Emblemes'**, Edward Collier, *1696, 33 x 42½ in. (83.8 x 107.9 cm), Tate Gallery, London.*
An exponent of trompe l'oeil, Collier specialized in skillful memento mori paintings, reminding the viewer of the inevitability of death. The warning motto *Vanitas vanitatum* sits with a skull, an hourglass, and a timepiece, while rich, tasselled silk, music, wine, and fruit suggest earthly pleasures. The clever juxtapositioning of the musical instruments leads us through the painting.

▼ **Flower Still Life with Curtain**, Adriaen van der Spelt, *1658, oil on wood, 18⅓ x 25⅕ in. (46.5 x 63.9 cm), Art Institute of Chicago.*
"Tulipomania" was coined to describe the craze of the 1630s, when some bulbs became as valuable as houses. Possessing a painting was a more reliable method of indulging this passion. Presented here as a quasi-secret view, the still life is in itself covetable. Artists could depict blooms together that were actually in flower at different seasons.

The Artist

Leon Battista Alberti, master of the Italian Renaissance, claimed that Narcissus, having seen his own beautiful face reflected on the surface of water, was the real inventor of painting. As he was discussing the artist's work in the context of a Greek god, we can accept his hyperbole and understand that he is trying to suggest that artistic activity is godlike. The function of the self-portrait is one of self-scrutiny but also self-advertisement, a demonstration of the kind of art the individual can produce. The artist must look long and hard, so looking at the work, we are often confronted by an overwhelming stare.

◀ **Self-portrait at the Dressing Table**, Zinaida Serebriakova, *1909, oil on canvas, 29½ x 25⅔ in. (75 x 65 cm), Tretyakov Gallery, Moscow.* An intimate view of the artist in her underwear, shown combing her hair, her direct gaze reflecting her bedroom and her busy dressing table. Arching her right eyebrow, she seems both to pose a question and to make a statement: "Yes, here I am, bare-shouldered, a model, but also an artist."

▶ **Self-portrait**, Romaine Brooks, *1923,*
oil on canvas, 46⅓ x 27 in. (117.5 x 68.3 cm),
Smithsonian American Art Museum,
Washington, DC.
The red button in Brooks's lapel is the
Légion d'Honneur, an artistic nod to Diego
Velázquez, who added the Maltese Cross
to his doublet in *Las Meninas* (*see p57*).
The grays are reminiscent of Whistler's
Nocturnes (*see p109*), but Brooks's red lips
and ghostly pallor are in sharp contrast,
her face framed with white collar wings.
Her eyes remain dark in shadow.

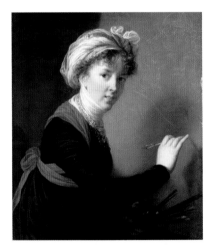

▲ **Self-portrait**, Elisabeth Louise Vigée-
LeBrun, *1800, oil on canvas, 31 x 26⅘ in.*
(78.5 x 68 cm), Hermitage, St Petersburg.
Using a porte-crayon to hold her chalk so
that she can outline her design onto the
canvas, LeBrun smiles at us, her brushes
at the ready. A sumptuous necklace, a
fashionable turban, and an eye-catching
red sash all confirm her professional success.

▲ **Self-portrait**, Artemisia Gentileschi, *1638–9,*
oil on canvas, 38 x 29 in. (96.5 x 73.7 cm),
Royal Collection, Windsor.
Gentileschi portrays herself as the allegory
of Painting, dressed in her best clothes and
with a symbolic medallion mask around her
neck. In a sense this is a double self-
portrait, as she documents her face while
also posing as the personification of art.

The Artist

Oscar Wilde suggested that every portrait painted with feeling is of the artist, not of the sitter. The artist reveals himself through the colored canvas. The self-portrait is therefore a concentration of what the artist wishes to say about his or her art, a physical rendering that aims to include a psychoanalytical evaluation. It may offer an insight into the essence of the creative unconscious, of ambitions and desires. Yet the act of painting a self-portrait is also implicitly about death, anticipating a life beyond the grave and commenting—sometimes ironically—on the vanity and brevity of human existence. In painting a self-portrait the artist both captures life and arrests it.

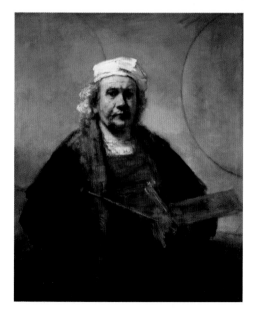

◀ **Portrait of the Artist**, Rembrandt van Rijn, *c.1665, oil on canvas, 45 x 37 in. (114.3 cm × 94 cm), Kenwood House, London.*
The light on Rembrandt's cap draws attention to his face and to his extraordinary expression, at once complicit, vulnerable, and compassionate. The parallel blacks of his coat echo the circles behind, examples of perfect form. Equally balanced, his mahl stick and brushes form a triangle with the square of the palette.

▼ Self-portrait with Saxophone,
Max Beckmann, *1930, oil on canvas,
27²/₅ x 55¹/₃ in. (69.5 x 140.5 cm),
Kunsthalle, Bremen.*
The artist's malevolent gaze and
brooding sexuality are the joint focus
here. The instrument is a serpentine
presence, held firmly by Beckmann,
who is dressed in a scale-patterned
dressing gown. Beckmann's
characteristic use of black forces
a dangerous Expressionist mood,
compressing the figure into the
limits of the space.

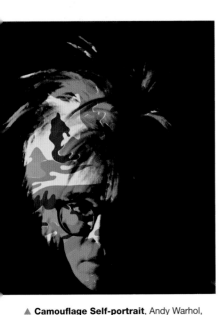

▲ Camouflage Self-portrait, Andy Warhol,
*1986, synthetic polymer paint and silkscreen
on canvas, 80 x 80 in. (203.2 x 203.2 cm),
Wadsworth Atheneum, Hartford.*
Warhol uses chiaroscuro—one side of his
face is in darkness, while his black-rimmed
glasses and the highlight on his nose focus
our attention on the lone, staring eye.
He is a master of graphic communication,
sharply contrasting the photographic image
with the abstract camouflage decoration,
implying that he is a chameleon.

PAINTINGS IN DETAIL

A variety of 50 engaging works examined in detail. These span the chronological range of the Western European tradition through five important themes of painting—portraiture, landscape, narrative, still life, and abstraction.

Portrait

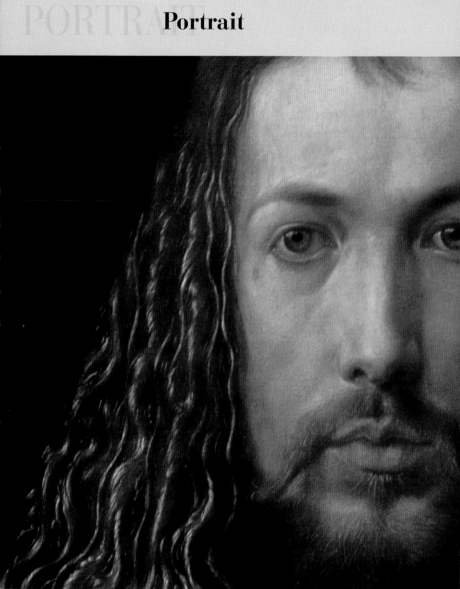

Albertus Durerus Noricus
ipsum me proprijs sic effin-
gebam coloribus aetatis
anno XXVIII.

Portrait

▶ **Interior at Paddington**, Lucian Freud, *1951, oil on canvas, 60 x 45 in. (152.4 x 114.3 cm), Walker Art Gallery, Liverpool.*

▼ **Christina of Denmark, Duchess of Milan**, Hans Holbein, *1538, oil on wood, 70½ x 32½ in. (179.1 x 82.6 cm), National Gallery, London.*

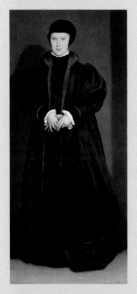

Portraiture has always been a way for an artist to earn money, and when there are no available paying clients, friends and family must suffice as sitters. These two full-length portraits are by artists who were famous and successful within their lifetimes. They specialized in what one might term "honest" likenesses of their sitters, who included royalty. In Freud's painting his friend, photographer Harry Diamond, is shown wearing his raincoat indoors. It looks strange, but in time this raincoat was to become a part of Diamond's trademark identity, so perhaps Freud's depiction is prescient. Beneath the coat, Diamond's slim frame and gaunt features make him seem older than 27, his age at the time Freud painted him. Diamond complained that the work took Freud six months to complete.

The portrait of elegant 16-year-old Christina of Denmark was the result of a three-hour commissioned sitting. At a time without film, photography, or video, portraiture played an active part in marriage negotiatons, and she was a potential bride for Henry VIII. The teal-blue background holds her shadow in the same way that Diamond's is cast on the wall behind him, lending both sitters presence and volume. She is painted onto three joined vertical planks of wood, a rigid support called a "table" in contemporary inventories. Despite the discretion of her widow's clothes, the fur lining of her sumptuous silk overgarment indicates her wealth and status, in sharp contrast to Diamond's shabby appearance in Freud's work.

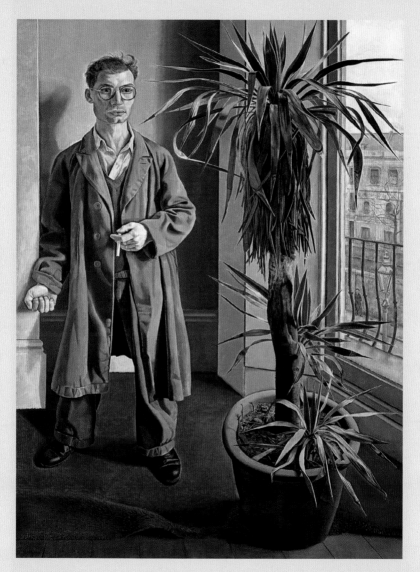

Self-portrait with Fur-trimmed Robe

Artist
Albrecht Dürer

Date *1500*

Medium & Support
oil on limewood

Measurements
26½ x 19¼ in.
(67.1 x 48.9 cm)

Location
Alte Pinakothek, Munich

Dürer was born 20 years after the invention of the printing press, and reproductions of his work fueled his fame. Self-portraits are testament to an artist's painting ability, but they also reveal how the artist wishes to be considered in the future.

Dürer's conviction and self-confidence is apparent in this work, and there is a coolness about the portrait that communicates as arrogance. What shocked its contemporary audience, and still has the power to shock today, is that he appears to depict himself as a Christ figure; many misconstrued the work as blasphemous. However, this loaded visual statement really defines him as a modern humanist. That he physically resembles the traditionally codified "Holy Face" is more likely an acknowledgment that his creative artistry was derived from a higher power. By adopting what his audience imagined to be Christ's features, Dürer focused the discussion on the new position and function of the artist within society. It elevated the debate about the modern autonomy of the artistic self to sit alongside the great themes of religion, art, and philosophy. His other self-portraits show him in a variety of guises, each revealing aspects of his personal belief and self-knowledge within the genre of portraiture. Here he is, 28 years old, at a transition point between youth and maturity. He lived for another 28 years.

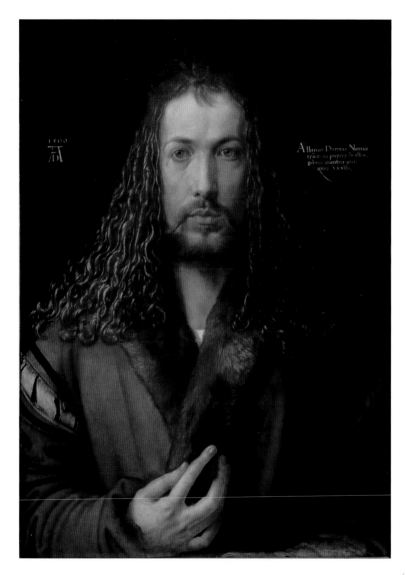

45

Self-portrait with Fur-trimmed Robe

▶ Full face

This full-face, confrontational pose is that seen in standard religious icons. Often the subject is shown with a raised hand pointing to the breast. Art historians suggest that Dürer's face has become imprinted onto our collective idea of the appearance of Christ. Genesis 1:27 records that "God created man in his own image." *Salvator Mundi* ("Saviour of the World") paintings of Christ show him as Dürer has depicted himself—with moustache, beard, and cascading, symmetrical brown hair.

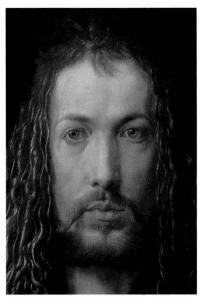

◀ Coat

The join of the sleeve reveals the white undershirt with slashes similar to those seen on the sleeves of Lodovico Capponi in Bronzino's portrait (*see p49*). His mantle is fur-lined, matching the revers of his turned-out collar. The wisps of mink-like fur form a delicate, detailed edge that invites comparison with the long, curling tendrils of Dürer's hair.

◀ Hands

Salvator Mundi is the term used for paintings that depict Christ using his right hand in a gesture of blessing. Here, the pose is different: The same hand is turned inward, pointing at the artist as he questions the weight of his responsibility as a uniquely gifted being.

▼ Monogram

Dürer's signature monogram— the capital "A" encasing a "D"— is set opposite Latin text that reads, in translation: "I, Albrecht Dürer of Nuremberg portrayed myself in everlasting colors aged twenty-eight years."

Lodovico Capponi

Artist
Agnolo Bronzino

Date *1550–5*

Medium & Support
oil on poplar panel

Measurements
45⅞ x 33¾ in.
(116.5 x 85.7 cm)

Location
The Frick Collection,
New York

Bronzino was taught by Pontormo, one of the masters of Mannerism, a style that the writer Vasari called "the modern manner." Mannerism was popular from about 1520 until it was displaced by the growing fashion for the Baroque at the beginning of the seventeenth century. In this larger-than-life portrait, an exquisite study of refined Mannerism, Bronzino modifies the exaggeratedly elongated style of Pontormo, focusing more on a clear delineation of form, but keeps his master's bright color palette.

The portrait encapsulates the promise and beauty of youth, its subject's elegance expressed in a clear, painterly style. Capponi was a page in the court of Cosimo I de'Medici. He fell in love but was forbidden to marry; after three years, de'Medici suddenly thawed and gave permission for the marriage, but insisted it take place within 24 hours. Capponi holds a miniature in a plain wooden frame the size of his hand, possibly depicting the woman he loved. It is inscribed with the words "Fate or fortune."

The sitter's left arm, hand, and pantaloons create a visual loop of light, arcing round to his right hand where the crux of the secret of the portrait lies. Our eyes pass swiftly from one side of the work to the other, pivoting on the point of his manhood, the highlighted bulbous codpiece. A relatively workaday pair of leather gloves without decoration, unlike his restrained but rich clothing, is held gently in his left hand.

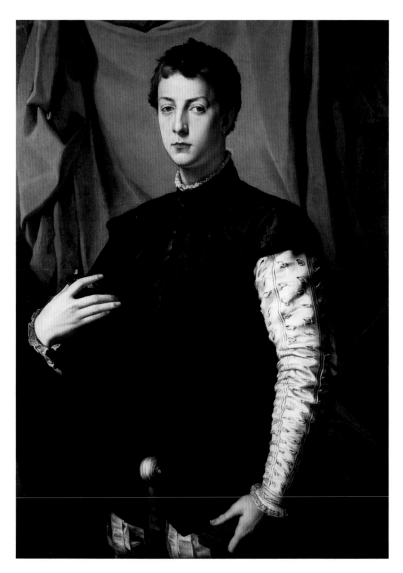

Lodovico Capponi

▶ Cuffs

Under a matching cape,
Capponi sports a black jerkin
of silk and velvet, with
minutely observed knotted
silk buttons, sewn buttonholes,
capped sleeves, and a discreet
ruff. His undershirt has cuffs
that frame his hands, and
these are adorned with black
embroidery and lacework. The
black and white are the
armorial colours of his family.

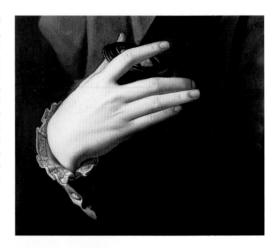

◀ Sleeves

The sleeves are slashed at
regular intervals, creating
a pattern in the fabric.
Through the holes one can
see his undershirt, which
is also white and probably
made from silk—proof of his
wealth, as keeping clothes
clean in the sixteenth century
was relatively difficult. At this
time, underlayers of clothing
would have been laundered,
but heavier overgarments
were generally simply
brushed to keep them clean.

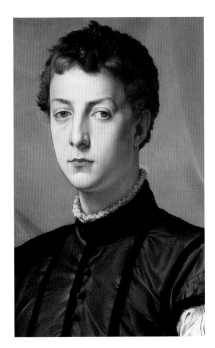

Capponi is handsome and serious, keeping the identity of the miniature secret from us. As a male heir with the potential to safeguard his family's line, Capponi had status as well as wealth. The portrait conveys this, reinforcing the effect with his fashionable attire and the sumptuous draped backdrop. His head, with its curly light hair, is framed by the paler unfolded area of the cloth.

▶ **Drapery**

Encased in black silk, his body fills the middle ground, bringing the pale elegance of his hands, nearest to us, into prominence. The space behind him is filled with green draperies, and though one might imagine they are there simply to fill the space, the purpose of the folds is more specific. The cloth both creates a richly colored backdrop and emphasizes the crisp beauty of the detailed monochrome portrait.

51

Marie de Raet and Philippe Le Roy

Artist
Anthony van Dyck

Date *1631 and 1630*

Medium & Support
oil on canvas

Measurements
Marie de Raet
84 x 45 in.
(213.3 x 114.5 cm)
Philippe Le Roy
84 x 45 in.
(213.3 x 114.5 cm)

Location
Wallace Collection,
London

Van Dyck rivalled Rubens with his ability to paint life-like portraits, revolutionizing the genre in England during Charles I's reign. Born in Antwerp, he spent some time in Italy, studying Titian in particular, and eventually made his home in London, never returning to his home country. His mark made, he died at the age of 40.

These astonishing full-length portraits were commissioned by Philippe Le Roy, the first recording his betrothal; the second, the consolidation of the union. He is ambitious, confident, and worldly-wise, yet with a hint of fragility. She, also clothed in dark silks with impasto white lace, is palpably insecure and vulnerable, a mere age 16 to his 34. Both sitters look us in the eye, and their faces shine like lightbulbs out of a froth of complex, beautiful, costly lace and translucent silk. The delicacy with which these fabrics are rendered, together with the modulation of tone, display van Dyck's great ability to communicate characterization through his mastery of technique. They are a gorgeous couple, a power duo, but she is shown as a living doll. In her hair a white feather fascinator captures our attention, contrasting with the texture of her strawberry-blond mane. She is symbolized by her dog, the miniature King Charles spaniel, a scrap of animated fur, he by his muscular, elegant, and alert greyhound.

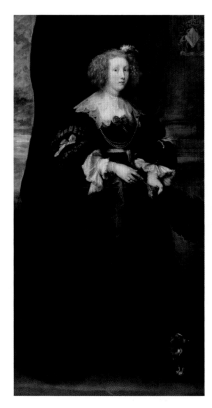

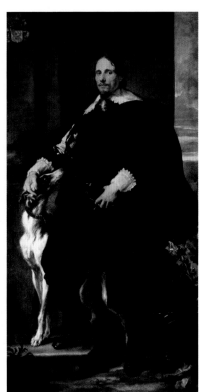

Marie de Raet and Philippe Le Roy

▶▼ Jewelry and lace
She is decked in expensive
pearls, white droplets parading
about her neck and slung across
her bosom, where they will swing
as she moves. A gold brooch with
diamonds sits in the center of her
chest, defining her as something
precious, as do her crisply
painted Brussels lace and
casually tied sleeve ribbons.

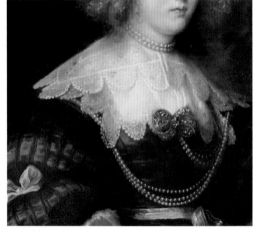

◀ Accessories and ornament
Her expensive black ostrich-feather
fan is as big as the little dog at her
feet, the curling tendrils of the
feathers dark against her slender,
unmarked white hands that have
clearly seen no manual labor. Her
engagement ring is the prominent
square-cut diamond that she wears
on her left thumb. The fluffy lawn
cuffs drape softly around her thin,
pearl-chained wrists. A white feather
fascinator sits in her blond curls.

▲ Coats of arms

The coats of arms in the upper corners of each portrait are important, as Le Roy is also using these paintings to advertise his status and the way in which his social position is augmented by his marriage and underpinned by the possibility of offspring with his new wife. They have been added by another hand after the paintings' completion; his reads "To serve God is to reign"; and hers, "Here below sadness, happiness above" (by implication, in heaven).

◀ ▲ Dogs

Van Dyck conjures an effect of sprezzatura, a sense of calculated nonchalance, together with the implication of innate superiority through Le Roy's relationship with his dog. The semi-casual way in which the hand cups the dog's head reveals the closeness and familiarity between the animal and his master, giving an impression of loyalty on the dog's part and power on the man's. But tenderness is also communicated in the way in which Le Roy's fingers weave themselves around the floppy ear, leaving the viewer with a feeling that there is softness and trust between the pair. Her dog is appropriately submissive and small, looking toward Le Roy.

Las Meninas or The Family of Felipe IV

Artist
Diego Velázquez

Date *c.1656*

Medium & Support
oil on linen

Measurements
*125⅕ x 108¾ in.
(318 x 276 cm)*

Location
Prado Museum, Madrid

Velázquez's work is astonishing, both as a portrait of the Infanta Margarita, daughter of Felipe IV, with her *"meninas,"* or ladies-in-waiting, in Madrid's Alcázar Palace, and as a pictorial distillation of the complexities of life. Some critics have considered this to be a visual treatise on the art of painting, as the figurative interplay reveals spatial and psychological relationships, both within the family and at court, including artistic self-analysis.

It is a monumental work with life-sized figures; if you stand in front of *Las Meninas* you feel as though you have become a part of it. The confident brushwork recreates mountains of deftly decorated clothing—the palest grays suggested by allowing the ground to show through—groups of people, the royal parents frozen in reflection in a distant mirror, and the artist himself. He is in control of the theater, at work on a canvas whose vertical format slices into the action of the room. Like Meindert Hobbema, in *The Avenue at Middelharnis* (*see p93*), Velázquez uses perspective to draw us into the story, re-creating this room as an extension of the art gallery in which we stand. Both the floor and the ceiling remain relatively blank, in muted color, and the walls are covered in other paintings that repeat the lines of perspective that anchor the composition.

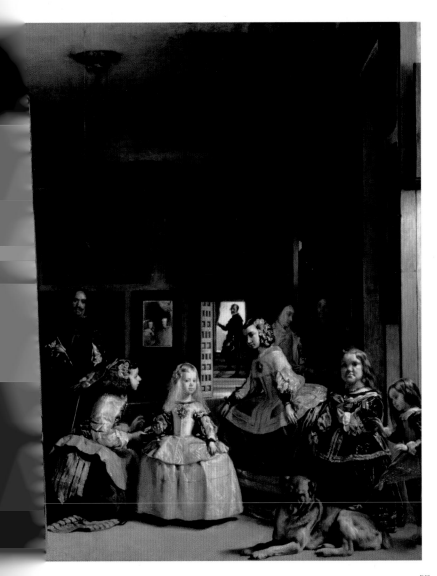

Las Meninas or The Family of Felipe IV

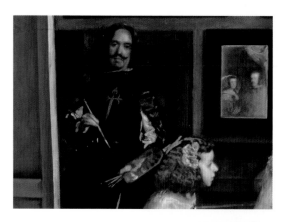

◀ **Self-portrait**
Velázquez looks us in the
eye and holds his brush
as if in the act of painting,
with a range of colors
displayed on his palette.
The Santiago Cross he
wears, denoting the Order
of the Knights of Santiago,
was added some time after
the completion of the work.
The King and Queen are
milky reflections in the
mirror's sheen at the back
of the room.

▶ **The Infanta**
At the center, bathed
in light, is the blond
Infanta, poised and
gravely surveying us.
She is attended by her
maids, María Agustina
Sarmiento (seen here)
and Isabel de Velasco.
The whole composition
revolves around the
formal and lifelike
depiction of this
5-year-old girl.

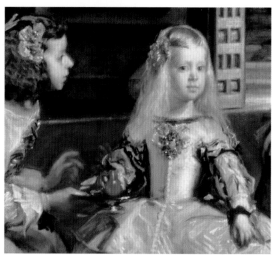

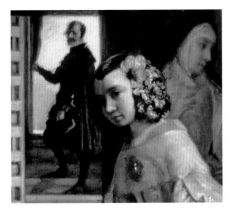

◀ Scale

José Nieto, the royal family's master of tapestries, lends a sense of movement in the background as, astride some steps, he turns in the doorway, silhouetted against an external light source. Light runs from the front to the back of the painting, and from the right, illuminating the dwarfs María Bárbola and Nicolasito Pertusato. Velázquez plays with scale and position. Adults appear small, with the children and dwarfs almost their equals in size.

▶ In the foreground

Nicolasito Pertusato, at the front, rests his foot playfully on the mastiff, who is almost as big as him: Patient and solidly beautiful, the dog secures that edge of the painting. The dog, nearest to the viewer, has a head almost as large as that of the Infanta, and a body as wide as her skirt. Between the figures of Velázquez and the dog, we can trace an elegant, serpentine line that pulls the whole composition together.

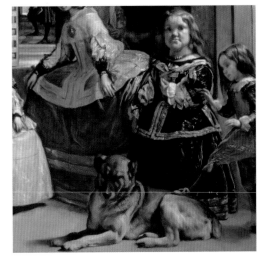

Mrs. Richard Brinsley Sheridan

Artist
Thomas Gainsborough

Date *1785–7*

Medium & Support
oil on canvas

Measurements
219.7 x 153.7 cm
(86½ x 60½ in.)

Location
National Gallery of Art,
Washington, DC

Gainsborough started his career painting the local Suffolk gentry, such as Mr. and Mrs. Joseph Andrews. He graduated to working in the spa town of Bath, and only after he had conquered that market did he arrive in the metropolis. London provided clients and wealth, offering the opportunity to develop his work in the way we see here.

The transparent, quivering tree that repeats the form of his sitter and friend is the key to this gentle, relaxed, and private portrait, redolent with atmosphere and love. Mrs Sheridan, before her marriage a well-known singer, gazes straight at the artist and, by implication, us, perched on a fake rock in an invented landscape. Gainsborough knows both her and her backdrop by heart and so can give full rein to re-creating her essence by conjuring the wispiest fronds with the most translucent of layered oil glazes. He orchestrates colors—her pink dress, the feathered russet leaves, and the pale blue waistband that differs slightly in tone from the sky—in the subtlest way. The sitter's feet look too small, and the "indoor" feel makes us suspect that it was painted in Gainsborough's Pall Mall studio, but the faults don't matter; the whole painting reads as an effective homage to his hero, van Dyck. On his deathbed, Gainsborough is reported to have said, "I am going to heaven and van Dyck is of the company."

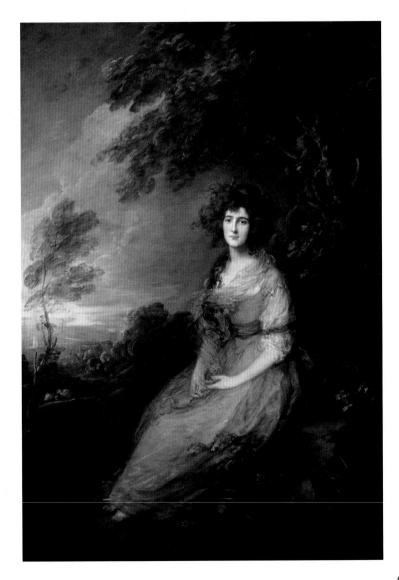

Mrs. Richard Brinsley Sheridan

▶ **Canopy**

The massed canopy of trees arching over the sitter's head is a medley of apple green, sharp viridian, and burnt umber. Russet and ocher match the pink of Mrs Sheridan's dress, and white shows through under the sky-blue glaze. Gainsborough used colors so liquid that they would apparently slide off his palette, and a dark-edged dried drip is visible.

◀ **Composition**

The sitter's gentle poise is zen-like amid the chaos of her ruffled hair and the mutable light-filled sky. Her body makes a crescent form, embraced by the tree and anchoring the composition, allowing our eyes to wander out into the dreamy landscape with two blobs of sheep in the middle distance beyond.

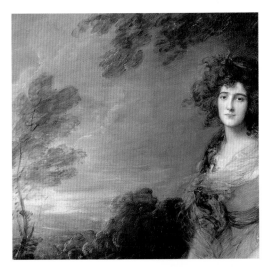

◀ **Layering**

The layering effect of successive colors and glazes demonstrates to us how Gainsborough gradually builds the physical substance of the work, creating tint and tone that read as three-dimensional. The sunset clouds in the background of the painting enhance the white glow of the subject's skin and the frothy fabric that seems to foam around her neck and arms.

▶ **Scarf**

A tress of the subject's hair is enmeshed in the folds of her pale, transparent chiffon scarf, its golden edge an impasto trail, with a hint of the blue sleeve ribbon repeating the curve. The artist's swift brushstokes are still apparent in the finished work, making the fabric seem to waft in the breeze.

Louis-François Bertin

Artist
*Jean-Auguste-
Dominique Ingres*

Date *1832*

Medium & Support
oil on canvas

Measurements
*45¾ x 37⅓ in.
(116.2 x 94.9 cm)*

Location
Louvre, Paris

Pro-Royalist Bertin was a close friend of Ingres, and friendship portraits have the added dimension of privileged access to the sitter. Ingres renders the 66-year-old realistically, recording his wrinkles and thinning hair. There are no obvious hints at Bertin's position as editor of the *Journal des Débats*, but his intellectual capacity is suggested by his pince-nez, intense regard, and overbearing pose—one that it took Ingres years to settle on. Although the work was an instant success this meant little to Ingres, as he preferred to be revered for history painting, portraiture then being deemed a lesser genre.

Ingres was the son of a painter and his studies under Jacques-Louis David confirmed him as a Neoclassical artist. He won the Prix de Rome and spent a total of 24 years in Italy, six of these as Director of the Villa Medici. He was as famous for his porcelain-like bathing beauties, such as *La Grande Odalisque* (1814), as for his portraits, the skin appearing "as smooth as an onion," just the way he approved of a painted surface. Although the revolutionary artist Delacroix was his contemporary, Ingres was his opposite in his traditional habits—this work, for example, is signed and named at the top in the conventional way. Some writers argue that Picasso was influenced by this portrait of Monsieur Bertin when he was painting Gertrude Stein in 1906.

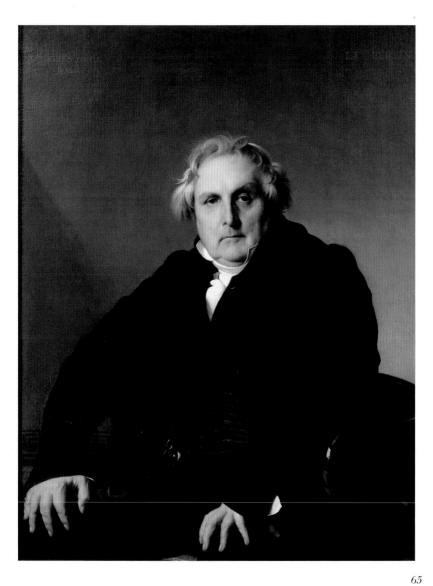

Louis-François Bertin

▶ **Steady gaze**

The tousled look of Bertin's square-shaped head topped with tufty, wispy, unkempt gray hair gives some sense of informality, but this is swiftly countered by the pristine, sharp crispness of his collar and cravat. He fixes his steady gaze just beyond us, one eyebrow slightly raised. The effect is to make the right eye appear heavy-lidded, which serves to counter the symmetry of the face. The shadows falling on the right enhance the length of the nose and the thin line of the lips.

◀ **Hands**

Bertin's hands press down, taking on the weight of his body, and his immutable personality is transmitted through the gesture of the fat digits. These hands communicate in a very different way from those of Sylvia von Harden in her portrait by Otto Dix (*see p 73*), for example, conveying power rather than contributing to the picture's sense of pattern and design.

The classical frieze on the wall behind Bertin's chair signifies the sitter's artistic predilection, adds a touch of class, and reinforces the general bourgeois air— Manet called Bertin the "Buddha of the bourgeoisie." His parted legs reveal a triangle of the red chair cover that reiterates other triangles in the composition, including the sitter's own monolithic form and the triangle of whites formed by the glint of his glasses, the window reflection in the polished wooden chair, and the cuff of his left sleeve.

▶ **Reflections**

The highly polished wooden tub-chair back shows a reflection of the window, indicating light entering the room from the left. It is perhaps a conscious nod to the mirror in Van Eyck's Arnolfini portrait (*see p23*), in which we see a similarly shaped window. The light also picks up on his golden pince-nez. Such details are small but important to the overall composition, which is dominated by blacks, grays, and browns.

Adèle Bloch-Bauer I

Artist
Gustav Klimt

Date *1907*

Medium & Support
*oil, silver and gold
on canvas*

Measurements
*54¹⁄₃ x 54¹⁄₃ in.
(138 x 138 cm)*

Location
Neue Galerie, New York

Klimt visited Venice and Ravenna in 1903 and was profoundly influenced by the early Byzantine mosaics of San Vitale, the effects of which he gradually distilled into the paintings that typify his so-called "Golden Phase." This portrait is a secular icon that combines intricate surface decoration with intensely realistic psychological portraiture, creating an intoxicating and memorable amalgam of the two disparate elements. Klimt was a Symbolist painter, and in 1897 was elected President of the Vienna Secession, an organization that stood against the conservative Viennese Artists' Association. He never painted a self-portrait, stating that anyone who wanted to know something about him ought to look carefully at his pictures and try to see in them what he was.

This doll-faced figure, whose disconnected black cap of wavy hair seems to have landed on her head, grabs our attention despite the plethora of gold around her. She glows like a lightbulb, and the black above her eyes and eyebrows intensifies this effect. Despite Klimt being a controversial figure socially, his work gained popularity and has been much reproduced. This factor has rendered his oeuvre difficult to judge without viewing the originals: perhaps, like the Mona Lisa, Adèle Bloch-Bauer has become a little too familiar to us.

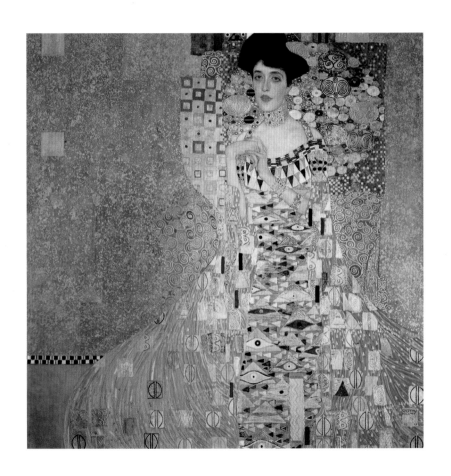

Adèle Bloch-Bauer I

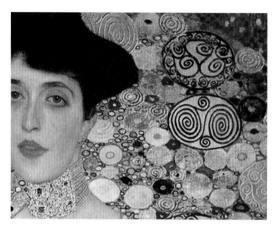

◀ **Face**

Face

The embellishment increases around the woman's head and shoulders, creating a kind of throne-back shape, from which her face looms out, red-lipped, red-cheeked, delineated within the eye socket and with a spot of white on the pupil—an old trick, also used by Rubens, to make the eye more arresting and shiny.

▶ **Formal pattern**

Egyptian-inspired eyes dominate the central section of her dress decoration, turning to bisected, black-bordered circles that sit within squares at the edges. Other sections have raised decorations that stand proud of the canvas. Klimt's signature is prominent within one such square. Pale, curved lines thread through this patterning that surrounds the woman's form.

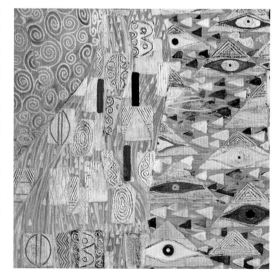

◀ **Flat decoration**
Unusually for a portrait, the canvas is square and large, over 4 feet tall. Klimt uses real silver and gold as flat decoration in a way that is more reminiscent of a pattern on wallpaper than a three-dimensional body. The space-defining black-and-white mosaic border is not unlike the frieze in the lower part of Monsieur Bertin's portrait (*see p65*).

▶ **Hands**
Bloch-Bauer's blue-veined hands are clasped in an uncomfortable-looking pose that creates another type of pattern. Her skin is greenish, echoed by the patch of grass (*see above*) that provides the only counterpoint to the gold and swatches of red. Our attention is held by the sitter's head, shoulders, and arms, even though they occupy only approximately one-eighth of the overall space.

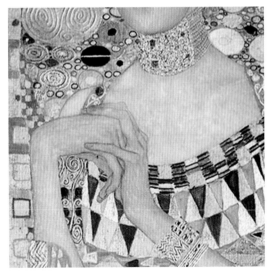

Portrait of the Journalist Sylvia von Harden

Artist
Otto Dix

Date *1926*

Medium & Support
oil and tempera on wood

Measurements
47⅗ x 35 in.
(121 x 89 cm)

Location
Musée National d'Art Moderne, Paris

This compelling portrait, although overtly simple and straightforward, is bursting with odd juxtaposition and visual comment. The trio of carefully arranged objects on the veined marble table acts as a counterbalance to the red-and-black patterned frame. Their formal shapes seem to inhabit a fixed tabletop world, opposing the sitter's smoke-trailing gesture. Despite the soft, pink, skin-like surface of the wall, we feel that von Harden herself is not warm, but officious and critical. She seems to be a distillation of intellectual café society, scary in her self-contained confidence.

Dix made her ugly, but von Harden loved the portrait, and in the 1960s was photographed posing with it, recalling that Dix had insisted he paint her as she was "representative of an entire epoch." The artist was 35 years old when he created this work in the *Neue Sachlichkeit* (New Objectivity) style, between the world wars. It verges on caricature, yet Dix's honesty harks back to Holbein's formal portraits. Dix fought in the First World War and became a fearless critic of war. He was labeled a degenerate artist, but called himself a realist and said that he had to see everything with his own eyes in order to confirm what it was like. This picture, with its lurid colors, still shocks and fascinates in the way that it subverts conventional portraiture.

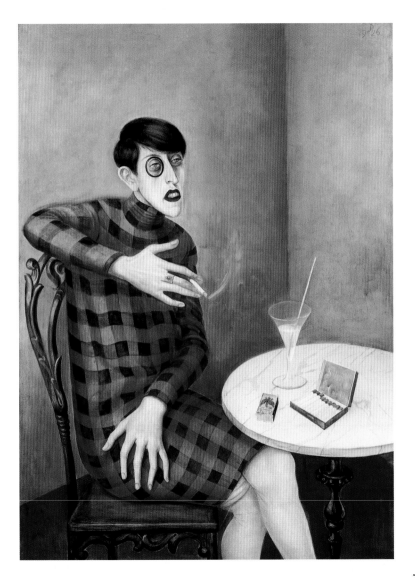

73

Portrait of the Journalist Sylvia von Harden

▶ Monocle

The monocle is attention-grabbing, the dark, circular form snapping von Harden's eye into focus, referencing the investigative nature of her writing, and reiterating the shapes of the cocktail glass and the table. Her boyish *Bubikopf* (bobbed) haircut emphasizes the thin, stretched oval of her face, her straight, elongated nose, and her scarlet, lipsticked mouth.

◀ Hands

The splayed fingers of von Harden's left hand hover over her thigh, while those of her right, one adorned with a hefty contemporary ring, are employed in gesturing with her cigarette and seem like spidery extensions of her slim form. She is shown as emancipated and modern, representing the *Neue Frau* (new woman). Despite the painting's title, von Harden was primarily an avant-garde poet and a writer of short stories.

▶ Tabletop

Dix paints all aspects of the work with the same degree of care, playing with three patterns: the foliated, carved nineteenth-century chair; the black-and-red plaid of von Harden's shift dress, and the blue-veined marble tabletop and its contents. The table sits on an hourglass-shaped stand, reminiscent in its form of a traditionally curvaceous female torso.

◀ Posture

Von Harden has been placed so that we view her slightly from above. She was a habitué of Berlin's Romanische Café during the Weimar period, and Dix has shown her perched on her chair like an odd but modish parrot. Although she is no beauty, she is almost elegant—if she would only secure the garter of her sagging stocking.

T. B. Harlem

Artist
Alice Neel

Date *1940*

Medium & Support
oil on canvas

Measurements
30 x 30 in.
(76.2 x 76.2 cm)

Location
National Museum of Women in the Arts, Washington, DC

"Life begins at seventy!" remarked Neel when her career revived after a retrospective at the Whitney Museum of American Art in 1974. As an artist, she had always been loyal to portraiture, which, together with her broad, unprejudiced choice of sitter, had perhaps impeded her professional success, particularly during the fashion for Abstract Expressionism.

Typically, Neel homes in on awkward portraiture, here combining capturing a likeness with a political comment on poverty and disease. Her subject is Carlos Negrón, the brother of her lover José Negrón, who, after moving from Puerto Rico to New York's Spanish Harlem, was diagnosed with tuberculosis. The gruesome remedy at the time was to remove ribs in an attempt to drain fluid from the lungs. We witness his mangled chest, caved in like a war victim's and outlined in black. Neel's painting of this crumpled body, prone on a day bed, is full of sympathy. But although the sitter is helpless, he is not hopeless, and there is a dignity in the rendition.

Neel greatly admired the German Expressionists, and her heavy black outlines around shapes and use of strong colors, such as purple, can be linked to the work of painters such as Beckmann (*see p37*).

T.B. Harlem

▶ **Fingers**

Black is used to delineate Negrón's delicate fingers , which are pointing to and holding his bright white bandage. The pose recalls Renaissance paintings of Doubting Thomas placing his fingers into the spear wound of the newly risen Christ. The juxtaposition of the white bandage straps and the thin fingers reinforces the message of the portrait: This man is very ill, and the bandage seems to sit uselessly in the place of his heart.

◀ **Bedcovers**

The beautiful lilac of the bedcover complements Negrón's tawny skin, which has areas of sallow yellow and nut brown, with lighter highlights. The colors act together in relation to the near black that engulfs almost half of the painting in a strong diagonal. The artist's speedy, vigorous brushstrokes are quite obvious, in aggressive contrast with the sitter's placidity.

◀ Expression

Negrón's collarbone appears to be detached, his neck sprouting from the cavernous body. Our attention is directed to his beautiful, languid head propped on the pillow, his dark, soulful eyes returning our gaze, their whites shining. His magnificently sculpted mop of hair informs his chiseled good looks, but the line of his mouth is limp with resignation.

▶ Shadows

Negrón is painfully thin, and the dark shadow behind his left arm emphasizes this. The carelessly arranged covers hint at his nakedness, with a suggestion of dark pubic hair revealed beneath his belly button. The white of the sheet acts as the top part of the sandwich in which his meager body is the filling.

Henry James

Artist
John Singer Sargent

Date *1913*

Medium & Support
oil on canvas

Measurements
33½ x 26½ in.
(85.1 x 67.3 cm)

Location
National Portrait Gallery, London

Although at first glance this might appear to be a gloomy painting, it is a stylish one that communicates much about the sympathetic temperament of the sitter. Sargent achieves this by the seemingly easy way he conjures the physicality of the novelist. Long years of practice inform his confident brushwork. Instead of fussing with extraneous detail he lays in the head boldly, fearlessly using chiaroscuro to real dramatic effect. Sargent's portrait of Madame Gautreau (known as the *Portrait of Madame X*), with its brazen depiction of a fashionable high-society subject, caused a scandal in France in 1884 and precipitated his move to England. This portrait also provoked a protest when it was shown at the Royal Academy in May 1914, when suffragette Mary Aldham attacked it. It was restored, and reveals Sargent at the top of his game: confident, able, in control of the atmosphere, and skilled at capturing likeness. The overall dusky tone means that any trace of light captures our attention.

Novelist Edith Wharton was the initiator of the commission, painted to mark James's 70th birthday. It was to be paid for by subscription, a mark of his popularity, although Sargent eventually waived his fee. Both sitter and artist were American, yet both had adopted England as their home. While Sargent reflected the image of Anglo-Americans, James's books dealt with situations arising from social and cultural differences between Americans and Europeans.

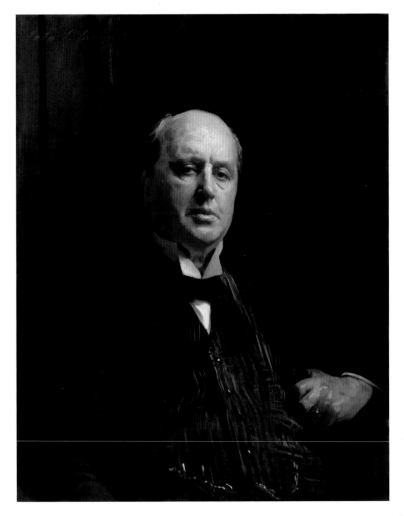

Henry James

◀ **Oak paneling**

The background to this eloquent portrait of the novelist is plain. Dark browns are modulated by verticals, making it seem as if he is in an oak-paneled room. The only color in the painting is the red of the artist's signature, placed in the top left-hand corner in a characteristic sloping script.

▶ **Light**

The brightest light hits James's forehead and can be followed down his nose, highlighting his philtrum and moving onto the slightly opened lips that suggest he is about to speak. The rounded shape of his head is set in contrast to the triple white triangles of light that make up his starched collar and shirt front. There is a mirroring of the triangular shape made between the eyes and nose and this triple white of his shirt. The color of the painting is spare, so the artist must rely on subtle tactics to create interest.

James's dark eyes meet our gaze intensely, with an assured and confident look. He commented that it was "a living breathing likeness and a masterpiece of painting." He bequeathed it to the National Portrait Gallery in 1916, proof that he was content that this portrait was the official, permanent record of his visage.

◀▼ **Highlights**

A pinprick of white highlighting each button lifts the somber tone and brightens the gray pinstriped waistcoat. These spots of light draw our attention to other highlights: the glint of James's gold ring, his watch chain, and the rim of his glasses propped in his pocket. The hand is shown at an angle, created by the left thumb hooked into the waistcoat pocket, and this creates a mild tension within the portrait.

Landscape

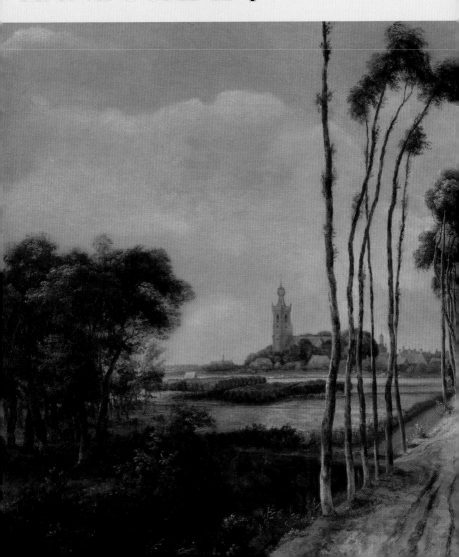

Landscape

Landscape painting can plunge us into an altered mental state, which distinguishes it from other genres. Think of the way that staring out of a train window can open you to the beauty of light on nature—on a cloud, tree, water, and land—creating a mental space for reverie. This chapter looks at depictions of real places and at created fantasy spaces.

Caspar David Friedrich's view is of the frozen sublime. The subject is otherworldly; the sky clear, crisp, and

▼ **Das Eismeer (The Sea of Ice**, also known as **The Wreck of the Hope)**
Caspar David Friedrich, *1823–4, oil on canvas, 38 x 50 in. (96.7 x 126.9 cm), Kunsthalle, Hamburg.*

▲ **The Marsh at Arleux**, Jean-Baptiste-Camille Corot, *1871, oil on canvas, 11 x 22½ in. (27.9 x 57.2 cm), National Gallery, London.*

eerie. We marvel at the cracking ice, and the emotional reaction it provokes is that it is equally beautiful and frightening. Despite the cool colors and the feeling of deadly quiet, the work is visceral and arresting.

Corot's small wisp of a painting has the opposite effect: We are subsumed into the mellow mists of the flat Picardy landscape. Friedrich's world is full of threat, while the fields here are wet but calm and quiet. There is a peaceful serenity at play here, created by the sparsely applied paint, the low-key color, and the simplicity of the composition.

Corot has distilled the essence of the marsh under the glimmer of silver light, capturing the scene for us to witness. He has scratched the white lines in the foreground directly into the paint using the handle of his brush, and their harshness contrasts with the moody, subtle, untrammelled view. It is far away from Friedrich's constructed ice layers, yet a feeling of loneliness is apparent in both works.

View of Toledo

Artist
El Greco

Date *c.1596–1600*

Medium & Support
oil on canvas

Measurements
47⅘ x 42⅘ in.
(121.3 x 108.6 cm)

Location
*Metropolitan Museum
of Art, New York*

The vibrant, deep color of this painting overwhelms the viewer. El Greco uses a citrus-sharp, almost fluorescent green to describe the landscape surrounding the city in which he spent the last 23 years of his life. He moves the cathedral to a new, imagined position in Toledo in order to fit it into the picture, to the left of the Alcázar, the royal palace, which is the crowning glory of the town. The buildings form a wavy, pearlescent necklace across the center of the work, and their bright highlights make them seem active. This dancing chain of light connects to the volcanic sky that erupts before us, darker where it is closest to the silhouetted buildings on top of the hill.

Toward the lower half of the painting the tempo changes from grand to domestic. The River Tagus in the gorge below the Roman Alcántara bridge is spotted with the figures of fishermen and washerwomen. We can distinguish the different species of trees, and recognize the fairy tale turrets of the Castle of San Servando. This attention to detail speaks of the humanity of the artist, as well as his ambition for the painting. *View of Toledo* is compact and complex, first seducing us with brash color, then beckoning us with a variety of different levels and interpretations.

View of Toledo

LANDSCAPE

◄ Sky

El Greco creates a moody sky, allowing the reddish-brown ground to show through the lighter paint and conjuring flickering clusters of cloud formations with heavy white paint. The swirling tints and tones animate the sky, making it seem alive above the ghostly turrets of the town. With his deft communication of the shifting atmospheric conditions, El Greco creates the impression of a raging lightning storm illuminating the curves of the hills and arc of the sky.

▶ River Tagus

Using tiny brushmarks the artist reveals reflections in the water and domestic details like the washing spread out on the ground to dry. The figures fishing have spears and look intently in the shallows for prey. A figure on a horse crosses toward the rock, leaving its own water trail.

▶ ▼ The city and nature

On the left is a dark-leaved tree with a pale serpentine trunk. If we follow the trunk upward we encounter the spire of the cathedral and, ultimately, the sky. The angularity of the flat-fronted pale buildings serves to reinforce the stepped, stage-like appearance of the architecture, the geometry of the manmade contrasting strongly with the green shapes of nature. Willows hug the water's edge with characteristically feathered foliage. The dry paint has been dragged upward, mimicking their growth and movement, and yellow has been blended with green so that we notice the natural growth in serial tufts. Above the trees is an enclosed garden containing a frame, perhaps for vines or other garden food crops to climb over. El Greco's signature in Greek, *Domenikos Theotokopoulos*, is emblazoned on a light-dappled wall by the water.

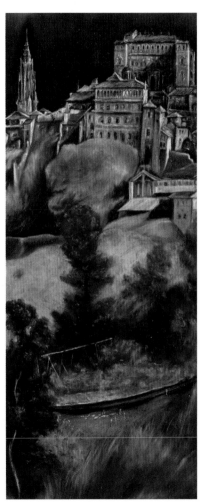

The Avenue at Middelharnis

Artist
Meindert Hobbema

Date *1689*

Medium & Support
oil on canvas

Measurements
*40¾ x 55½ in.
(103.5 x 141 cm)*

Location
*National Gallery,
London*

Born in Amsterdam, Hobbema was apprenticed to landscape painter Jacob van Ruisdael at the age of 15. This is his most celebrated work, created 20 years after he stopped painting professionally in favor of working for the Amsterdam association of wine importers. At first glance, the work seems to be exclusively about using the avenue of trees to illustrate the optical trick of perspective and the ruse of the vanishing point (*see* Uccello's *The Hunt in the Forest*, *p136*). But while it is true that Hobbema's landscape is anchored by the avenue, using it as a reliable pictorial base allows him the freedom to develop all kinds of other visual delights. It is an accurate view that has barely changed since the seventeenth century.

Striding towards us is a man with a gun slung over his shoulder, his dog at his heel. Other figures diminish into the distance, where the reddish tones of the ruts in the foreground gradually fade and disappear. The dyke water on either side of the road supports different kinds of wild plants, some in flower, and a range of delicate greens has been used to describe the variety of groundcover in the middle distance. The severe compositional structure of Hobbema's painting allows us to enjoy a whole world of quotidian life, three and a quarter centuries later.

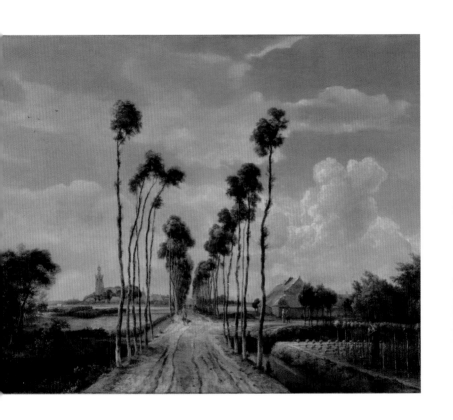

The Avenue at Middelharnis

▶ **Gardener**

The artist presents us with another kind of artistry—the keenly manicured rows of fruit trees to the right and left of the avenue. A gardener, with his tool bench beside him, carefully trains up a tree. In an exquisite, timeless detail we see him using his mouth to hold an extra peg.

◀ **Untamed land**

To the left is a wild, untamed piece of land. Hobbema aligns this with a gushing water pipe, a flock of birds overhead, and an open, cloud-filled sky. We can almost hear the rustle of the leaves, and the giggle of the woman as she and her lover flirt together near the barn to our right.

▶ Manmade landscape

Throughout the painting we are presented with the opposing elements of natural chaos and manmade specifics—for example, the two church spires, the water tower and the dyke bridge struts, the weather vanes, and the stepped roofing which is so typical of the Low Countries.

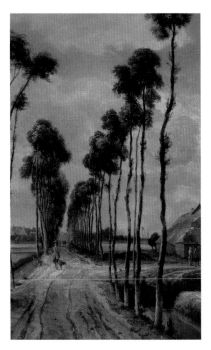

◀ Composition

Like Whistler's *Nocturne* (*see p108*), the painting is roughly divided into three horizontal bands, consisting of the pale foreground road, the freely worked bushy green tops of the spindly poplar trees that make up the avenue, and the free-form blue-and-white clouded sky.

Hampstead Heath with Bathers

Artist
John Constable

Date *c. 1821–2*

Medium & Support
oil on canvas

Measurements
9⅔ x 15⅖ in.
(24.4 x 39.1 cm)

Location
Metropolitan Museum of Art, New York

This modest picture is a far cry from what Constable called his "six footers," but, like Corot's view of Arleux (*see p 87*), it reveals the painter's natural sensitivity toward the changing landscape. He was familiar with the Heath, and went there, as Londoners still do, to escape the city bustle. He made Hampstead his permanent home in 1827. Obsessed with recording mutating cloud formations, Constable made around 100 oil sketches between 1821 and 1822, a practice he called "skying." He wrote, "A landscape painter who does not make his skies a very material part of his compositon neglects to avail himself of one of his greatest aids ... The sky is the 'source of light' in nature—and governs every thing."

Constable often left the pre-prepared brown ground of the canvas showing through to act as a mid-tone and give instant depth to his abstract atmospheric white-and-blue cloudscapes. We feel his desire to note a place and a time, and to mirror the reality of life. He transmits the truth of what he sees, and claims his place in landscape painting at a time before the technical developments that allowed artists to paint easily outdoors, and he ultimately gave rise to the Impressionist movement.

Hampstead Heath
with Bathers

◀ Middle ground

Physically small but packed
with information, this is
an exquisite snapshot of a
picture. The artist includes
this strip of land in the middle
ground to contribute scale and
depth, in the same way as
today one would compose a
photograph. A lone cow is
evoked with a brief spin of
liquid white oil, a simple
addition that seems almost
like an afterthought. Another
version of this view by
Constable is in the collection at
Kenwood House, situated on
Hampstead Heath.

▶ Distant figures

The tiny moving figures
recall those in El Greco's
View of Toledo (*see p88*).
Both works reflect the
artists' ability to observe,
interpret, and celebrate the
world around them. Their
respective love of the views
they have chosen can be
seen in their use of the fresh
tints of greenery to enliven
their pictures, together with
the bright whites of their
boisterous skies.

◀ Clouds

Constable's deft brushwork magically communicates the atmospheric tensions and pressures in the sky. The clouds scud and shudder past, and we can feel the hot breeze on our cheeks; it's a glorious summer's day.

▼ Pond

In this keenly observed southern English scene, with a gentle slope of land leading down to the pond in the foreground, the natural spring water—the source of the Fleet River that flows from Hampstead to empty into the Thames near St Paul's Cathedral—is peppered with bathers frolicking and cooling off.

Snow Storm—Steam-boat off a Harbour's Mouth

Artist
Joseph Mallord William Turner

Date *c.1842*

Medium & Support
oil on canvas

Measurements
36 x 48 in.
(91.4 x 121.9 cm)

Location
Tate Gallery, London

Successful and controversial, Turner painted works that today would be deemed abstract. Eminent writer and critic John Ruskin who, 35 years later, criticized James McNeill Whistler for "flinging a pot of paint in the public's face," championed Turner, defending him publicly in his book *Modern Painters* in 1843. Both these Chelsea artists loved the water and were passionately driven by their art.

Sea and sky whirl in a vortex of wave motion, disappearing into the dark black hole that is the central core of this work. The painting relies on monochrome for impact. The whole composition operates through the interplay of extreme dark and light. The dark gives the work depth and distance, and the central white impasto forms its vibrant electric heart. There is an apocryphal story about the aged Turner being tied to the mast of a boat for four hours to experience just such a storm, better to understand the terrifying power of nature and translate the experience into his painting.

Turner was certainly after something more complex than a simple depiction, but the reviews of this work were disparaging. *Athenaeum* magazine commented, "This gentleman has, on former occasions, chosen to paint with cream, or chocolate, yolk of egg, or currant jelly—here he uses his whole array of kitchen stuff." Another reviewer suggested the painting was nothing but "soapsuds and whitewash."

The painting's full title—*Snow Storm—Steam-boat off a Harbour's Mouth making Signals in Shallow Water, and going by the Lead. The Author was in this Storm on the Night the Ariel left Harwich*—seems to confirm the story about Turner going through such a storm personally, but in reality no boat called Ariel was recorded for the supposed time and place.

It has been speculated that perhaps, too, Turner wished to reference the storm at the start of Shakespeare's *Tempest*—"the wild waters in this roar... The sky, it seems, would pour down stinking pitch"—and used the name Ariel for this reason.

Snow Storm—Steam-boat off a Harbour's Mouth

◀ Paddle steamer
The wheel of the paddle steamer can be vaguely made out at the center of the composition, and a few dabs of white have been used to pick out the struts. Further details of the smoking funnels are barely perceptible as they are lost in the furor of wet and wind conjured in whirls of paint. The wide range of brushstrokes fuels the atmosphere of turmoil.

▶ Chaos
Without a reference point in the foreground, we don't know where we are in relation to the scene, so even the viewer feels vulnerable in front of the canvas. The swirling unrest of rain, mixed with a chaos of sea, thunder, lightning, and the plume of brown smoke from the steamer's funnel, combine for a deeply unsettling effect.

▶ Color palette
A dash of the palest blue chimes with a note of lemon yellow, combining to suggest some kind of hope amidst the black despair of the churning sea. The paint consistency varies in different areas of the work. Here, dry, pale oil skids across the surface of the painting, leaving drag marks that seem to conjure up both the weather front and the wind direction. We view this as if looking through the advancing weather.

◀ Tempest
Critics have speculated that Turner wanted to reference the storm at the start of Shakespeare's *Tempest* —"the wild waters in this roar... The sky, it seems, would pour down stinking pitch"—in the title, and named an imaginary ship Ariel to make the link even more evident. The drama of his painted storm is certainly equal to its literary equivalent.

Racehorses at Longchamp

Artist
Edgar Degas

Date *1871, possibly reworked in 1874*

Medium & Support
oil on canvas

Measurements
*13²/₅ x 16¹/₂ in.
(34 x 41.9 cm)*

Location
Museum of Fine Arts, Boston

This small, lightly painted work is a snapshot of the moment when riders and horses mill about at the start or the end of a race. It is set at Longchamp in Paris, but this could be any racing venue, from Saratoga to Epsom. Rather than concentrating on the hats and the fashions of the *beau monde*, Degas celebrates the colors worn by the jockeys, and as he loved horse racing as much as the ballet, one senses these are the real thing and not a fanciful invention. He catches the variety of movement, and looking closely, we notice the articulation of the horses' heads, their various markings, and even the different angles of their riders' hats. Seen alongside *The Horse Fair* by Rosa Bonheur (*see p152*), this is the quieter picture of the two.

Degas was also fascinated by Eadweard Muybridge's 1878 photographic experiments into the nature of a horse's movement, carried out in Stanford, California. Muybridge concluded that all four of the horse's legs leave the ground simultaneously when it trots and gallops, a fact previously disputed, and Degas's subsequent paintings illustrate the discovery. In 1875, critic Edmond de Goncourt wrote that Degas was "… an excessively sensitive painter quite aware of the specific personality of each thing. Better than anyone I know he has caught the spirit of modern life."

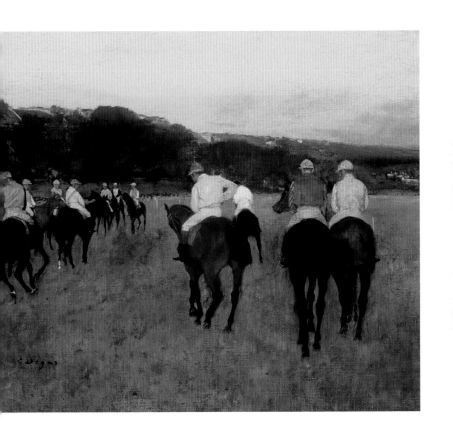

Racehorses at Longchamp

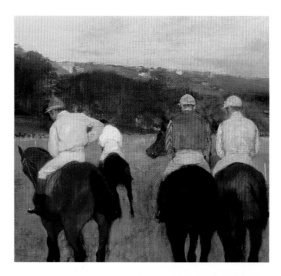

◀ **Color**

The middle of the picture is a suave combination of blocks of color and implied activity. The pink satins tastefully echo the pale band of cloudy sky. The riders nearest to us have their backs to the viewer, with the result that we read their bodies as similar repeated shapes enhanced by color. This device adds to the syncopated rhythms of the painting: The spots of color seem to flicker as we look at them, encouraging us to read them as movement within the picture.

▶ **Perspective and detail**

The background acts as a foil to the complexities of the foreground, with white fence barriers delineating the borders of the space. What dominates and attracts our vision, however, is the bright red cap on the head of the central rider. The fearless use of carmine brings to mind the work of Corot, who often uses this device to lift a composition.

▶ Movement

To the left is a kerfuffle around a shying and a biting horse, their coats an orchestrated arrangement of browns and tawny blacks. They vie for our attention with the patterns created by the horses' legs. These dark, modulated, vertical forms set up another rhythm for us to enjoy. The three dark rumps in the foreground recall the back view of the horse in *The Conversion of Saint Paul* (*see p21*).

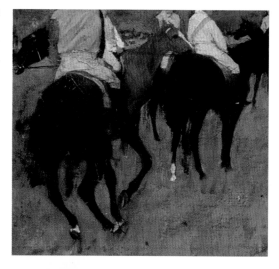

◀ Two riders

The two riders nearest us seem to be in conversation, the yellow-clad rider's head slightly turned to his companion, who has chevroned sleeves. Subtle details are suggested—we can see their ears, and dabs of white suggest silver stirrups. Their horses' tails are tightly cropped and the hooves are lifted sequentially away from us.

Nocturne: Blue and Silver—Bognor

Artist
James McNeill Whistler

Date *1871–6*

Medium & Support
oil on canvas

Measurements
19⁴/₅ x 34 in.
(50.2 x 86 cm)

Location
Freer Gallery of Art,
Smithsonian Institution,
Washington, DC

A favorite of Whistler, "One of my finest, perhaps the most brilliant," this work was shown at the Galerie Goupil in Paris in 1892. Whistler used the term "nocturne" to describe his uniquely charged paintings of scenes at dusk and at night. An American, he lived in London and the *Nocturnes* often depict his adopted home territory of Chelsea and the Thames. He painted by day in his studio, and his patron, Frederick Leyland, gave him their name. "I can't thank you too much for the name as a title for my moonlights! ... it is so charming and does so poetically say all I want to say and no more than I wish," Whistler wrote in November 1872.

Whistler uses flattened forms for these asymmetrical compositions, inspired by Japanese printmakers such as Utagawa Hiroshige. He used a reeded design to decorate his own frames—a type known now as a "Whistler frame"—to control the entire effect, understanding the power of a cohesive whole to create a integrated statement. When criticized for overpricing work that took little time to make, Whistler retorted that it had taken him a lifetime to learn how to do this.

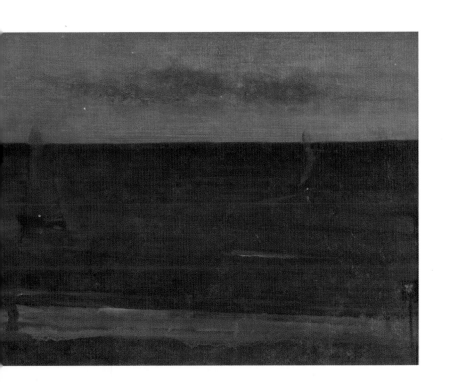

Nocturne: Blue and Silver—Bognor

◀ **Butterfly signature**

Whistler's initials gradually morphed into a butterfly-shaped monogram over the years. Just visible on the far left we see what may be an instance of it masquerading as boat sails, and it is definitely present on the right, where the artist uses a placard to support the rectangular cartouche containing a butterfly, the device used as his signature. The translucency of the paint is delicate: We see the sails as almost imperceptible verticals against the horizontal layers of the sea.

▶ **Night details**

Two charcoal clouds hang heavy and low in the sky. The night fishermen, their feet in the spume, toss their nets into the rollers, a lobster pot beside them. Three barely visible sailing boats glide effortlessly on the dark surface. Two round yellow pinpoints of light illuminate their trail.

◀ The sea

The advance and retreat of the sea is shown by a feathered edge, achieved with different densities of paint. The blue contrasts with the deep, dark skyline where the color is most intense, while the use of white makes us aware of the shapes of the waves by indicating their forms in relation to the light of the moon. You can almost hear the sea as it grazes the shoreline, the only sound a rhythmic breath as the small waves break on the dark shingle.

▶ Treatment of space

Dreamy, evocative, and mesmeric, the stars are out in this modest south-coast seascape in which the artist has substituted blue for his more usual dusty gray-beige palette. We know by the light in the sky that the moon is up. Four simple bands of color suggest the receding space of the English channel before us.

Percher de Blanchisseuses

Artist
Berthe Morisot

Date *1875*

Medium & Support
oil on canvas

Measurements
13 x 16 in.
(33 x 40.6 cm)

Location
National Gallery of Art,
Washington, DC

Morisot's grandfather was famous rococo painter Jean-Honoré Fragonard; she was taught by Corot and was Manet's close friend (she married his brother). Here she paints *en plein air*—"out of doors"—recording the time-honored ritual of hanging out the laundry, but on an almost commercial scale, reflecting the contemporary demand for frequently laundered linens. We see the rows of clothing hung between the allotment and the villa garden. The distant smoking chimneys place us within sight of the urban sprawl of Gennevilliers, northwest of Paris. The painting was shown in the second Impressionists' exhibition of 1876, and was a new twist on the old genre theme of painting everyday life, a kind of modern Hobbema. That year Morisot also painted *In the Wheatfields, Gennevilliers*, a scene that celebrates the produce of the land while repeating the smoking urban backdrop. The Impressionists wanted to focus attention on the way in which the land was changing as a result of industrial "progress," and often juxtaposed signs of industrialization with picturesque leisure activities, constructing alternative, modern *fêtes champêtres*. Argenteuil, a favorite spot for Monet, was just three miles east of Gennevilliers, and was described as *la nouvelle cité*, after growing from a population of 8,000 in the 1870s to 12,000 by 1882.

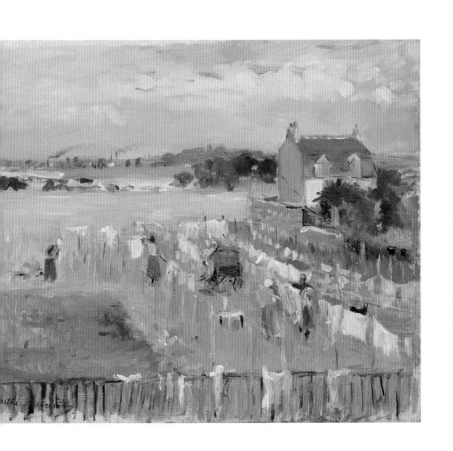

Percher de Blanchisseuses

▶ **Laundry work**
A woman with her back to us stretches up and pulls the cloth along the line to flatten and secure it. The tipped-up cart among the clothing lines suggests that the laundry is a small business rather than purely a household chore—it is a two-wheeled affair such as might be pulled by one person to transport light goods. The overall mood of the color scheme is pale and literally washed out.

◀ **The gardener**
The man with a loaded wheelbarrow tends the vegetable patch, half of which is bare earth, suggesting that the season may be late summer. His presence, and the suburban allotment, are reminders that this is no longer an open landscape plain encompassed by a bend in the Seine.

▶ Foreground figures
The women in the foreground of the painting have paused in their work. One gathers laundry, stacking it over her left arm as she pulls a sheet from the line. She appears to be in conversation with the other, who wears a white headscarf indicated by a mere dollop of paint—which has the effect of making her blend in with the sheets around her. These white daubs work together to bring the foreground closer to us.

◀ Washing details
The laundry is draped over the fencing that spans the whole of the lower section of the painting, forming a barrier between the viewer and the action. The repetitive uprights echo those of the clothesline poles and the distant chimneys. Together with the pale drapes of laundry, they bring a sense of movement and rhythm to the painting.

Mont Sainte-Victoire & the Viaduct of the Arc River Valley

Artist
Paul Cézanne

Date *1882–5*

Medium & Support
oil on canvas

Measurements
*25⅓ x 32⅕ in.
(65.5 x 81.7 cm)*

Location
*Metropolitan Museum
of Art, New York*

Cézanne spent his whole life battling with this mountain. He declared he wanted to make museum-quality work depicting it, and many pictures survive to testify to his obsession. In this painting, rather than let the whole mountain take center stage as he does with other pictures of the same subject, he shifts his beloved cone to the background, almost hiding it behind a copse of pines.

This deliberate picture appears balanced and in tune with itself. We look down on the view and across at the unassailable Sainte-Victoire. From this viewpoint we can contemplate the vastness of nature, and take in the plain tamed by humans, while at the same time realizing that this civilized cultivation is nothing compared to the ancient rock formation of the mountain. Cézanne reserves his characteristic pinky mauve-gray and slate blue for the mountain, which seems to sit like a pale resting giant that dominates all below it under the baby blue translucent sky. The brushwork forms a patchwork of directional multi-colored dabs of related hue, the thin layers of color creating a prismatic, jewel-like surface. The artist works with control as well as passion. The result is a classical look, rather than the avant-garde modernism with which he is usually associated.

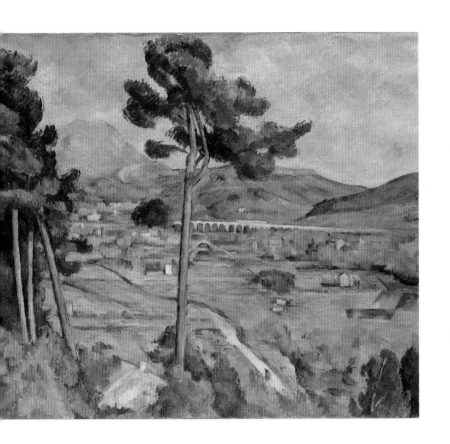

Mont Sainte-Victoire & the Viaduct of the Arc River Valley

◀ Framed by trees
The left-hand grouping of pine trees anchors the composition, seeming to support each other in a bunch, and creating the darkest part of the painting. This species of pine identifies the landscape immediately; it is strongly redolent of the south of France, the turpentine scent of its needles and sticky sap exuding into the hot air.

▶ Solitary pine
The central pine almost bisects the painting, elegantly upright and alone. It is itself cut through by a wandering road—we can just perceive a bowed figure walking along it in the foreground. The horizontal line of the viaduct cordons off the bottom quarter of the work, creating a calmer space with the cultivated, verdant plain.

◀ The viaduct

The off-white viaduct is carefully painted in thicker paint, emphasizing the repetitive clear curves of the arches, and echoing the nearside vertical pine trunks that frame the painting. This imposing manmade structure draws our eyes toward the base of the mountain in the same manner as the pale meandering road that connects the foreground and background.

▶ Houses on the plain

There are houses dotted around the landscape, their solid walls rendered in a thick cream color, with shades of ocher and bluish grays. The homely, fresh, yet grounded colors of the lower part of the painting spread out before the viewer like a subtly shaded patchwork quilt. A roof in the foreground directly below the viewer arrests our attention, bringing us up with a start.

Western Forest

Artist
Emily Carr

Date *c. 1931*

Medium & Support
oil on canvas

Measurements
*50½ x 36 in.
(128.3 x 91.8 cm)*

Location
*Art Gallery of Ontario,
Toronto*

*"Material in the West
was expensive, space
cheap enough. I bought
cheap paper by the
quire. Carrying a light,
folding cedar-wood
drawing board, a bottle
of gasoline, large bristle
brushes and oil paints,
I spent all the time I
could in the woods."*

FROM *HUNDREDS AND
THOUSANDS, THE
COMPLETE WRITINGS
OF EMILY CARR*

Initially landscapes were rendered as vignettes within Christian narrative painting, or as backgrounds in portrait commissions from landowners, until landscape gradually morphed into a subject in its own right. Here it exists as a kind of portrait of a country, albeit an abstracted one, as Carr's work has come to be seen as representative of Canada. These cedars, like great mushrooms caressing the sky with their variegated green canopies, are an amalgam of reality and interpretation. They celebrate the ancient woods of British Columbia and, by implication, the First Nations, the people who lived there. Like the wood in Paolo Uccello's *The Hunt in the Forest* (*see p136*) there is a mystery in the darkness of the inner sanctum, one that recalls the primal unconscious hazards of the fairy tale.

After periods studying in San Francisco between 1890 and 1892, in England in 1899, and in France, where she was exposed to the avant-garde paintings of the Fauves, in 1910, Carr was isolated in her practice. A uniquely avant-garde artist of her time, working in what was then still a relatively wild pioneer country, she made frequent trips into remote parts of Canada, traveling alone, making paintings and writing from firsthand experience.

Western Forest

▶ Canopy

Suspending time, Carr offers us a retinal hit, introducing the cool forest as a special private space for sharing—we can simply drift over the surface of the work, lost in quiet contemplation. The viewer who is able to develop a relationship with the painting by looking at it repeatedly will find that it can function like a meditation mantra.

◀ Portrait format

Unusually for a landscape, not only is the painting portrait-format, similar to that of O'Keeffe (*see p25*) —it should be viewed upright—but the entire composition stresses this orientation. The main trunks span two-thirds of the height of the canvas. Their surface is rendered using a mixture of colors, matching the hues of shadowy bark.

◀ Shades of green

The greenery is rendered in gentle curves, like waves on an unruffled sea. The arcs are similar to those used by Turner in his storm painting (*see p 100*), but here all is calm. Carr's use of the serpentine flow of natural light and form to bind the composition together reveals a synchronicity with *Der Blaue Reiter* and Futurist movements. Here, this flow sets up a repeating rhythm that recedes into the painting's depths.

▶ Light and shadow

The repetition of shapes and shadows as they recede into the distance conveys the sensation of looking through a dark wood through which only occasional patches and shafts of light can penetrate. The forest can also function as symbolic of adventure, danger, or the unconscious mind. These shadows are those of folklore and reality translated through paint. In real nature we might spot a bear or, here, imagine one behind the tree.

Study for Eagle Head, Manchester, Massachusetts

Artist
Winslow Homer

Date *c. 1869*

Medium & Support
oil on wood

Measurements
*9½ x 21¼ in.
(24.1 x 54 cm)*

Location
*Metropolitan
Museum of Art,
New York*

This little plank of wood captures the movement of the rolling waves as they crash gently onto the shore. A simple oil sketch, it encapsulates a lifetime of the artist looking at the waves and studying the rolling hoop of sea moving along the shore, breaking in a continually unfolding sequence. It is a sketch for a far more illustrational work that was to depict three women wringing out their skirts. The sketch, though, shows an ordinary day with a flat green sea and a pale blue sky with nothing special to distract our attention from the sweeping arc of the bay and the dark outline of the promontory beyond.

Boston-born, Homer was equally skilled at painting an angry sea, with waves hitting the scarred rocks of Maine and Massachusetts, and in these works his shore scenes recall those that Monet painted of the Brittany coastline.

Homer worked first as an illustrator. In 1873, during a summer stay in Gloucester, Massachusetts, he took up watercolor and displayed a natural talent for the medium. Two years spent in the northeast of England, between 1881 and 1882, darkened his palette. His studio in Maine, where he worked for much of his last three decades, was close to the water's edge.

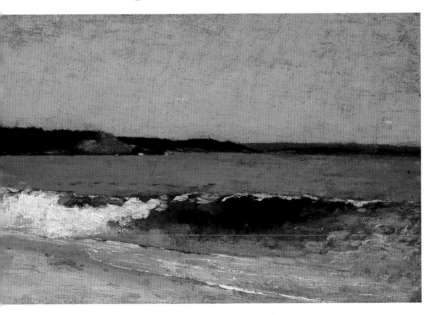

Study for Eagle Head, Manchester, Massachusetts

▶ Paint textures

In the middle distance, the mottled effect of dabbing dry paint onto the surface creates the mixing spume as the wave breaks. Colors used in the lower right are repeated here, but knocked back by added white and melded together to simulate the effect that occurs in real life where sea meets shore. A translucent shade of terre verte spins and jumps along the water's edge.

◀ Depth and color

This work could pass as an Impressionist painting. In fact, Homer spent a year in France in 1867, but this was well before the first Impressionist exhibition, which opened in 1874. His skill enables us to experience his deeply personal love of the sea. Here, the shadow of the curling wave is shown to be deep green, surrounded by a medley of mauve, acid green, and eau de nil. Transparent patches reveal the wooden surface of the board beneath.

▶ Wave crests

The crest of the wave is outlined by the deep shadow falling under it. The sharp white is heightened by the darkness in the foreground. The jiggling impasto of the curling lip of this wave reinforces the black patch beneath it, creating a clear visual echo of the dark coastline beyond.

◀ Foam on the shore

The mesmeric motion captured here also suggests the sound the breaking waves make as they reach land in repetitive formation. The thinner dribbles of pure white along the edges mimic that residue of foam when the wave has broken and the main body of water withdraws from the shore.

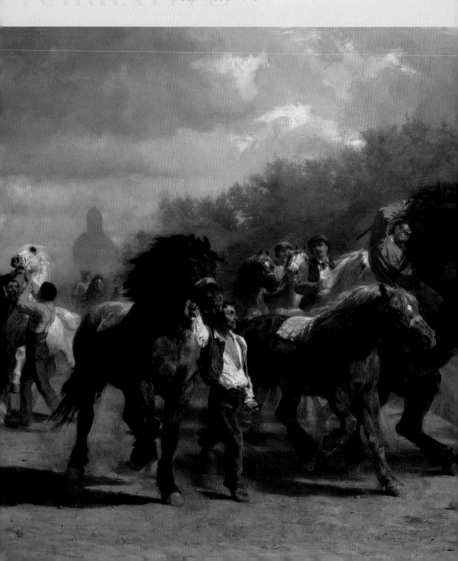

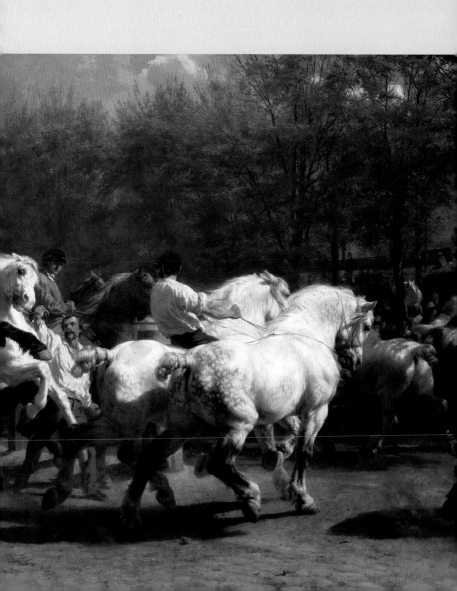

Narrative

Every picture tells a story, although a good story doesn't always make a good painting. Narrative paintings often retell familiar tales, such as those from Christian or Hindu mythologies. Art communicates, and it can be useful as well as uplifting. In revolutionary Russia, for example, trains were painted with cartoons and slogans to reach illiterate comrades, while in India, figurative temple paintings recount the fabulous exploits of gods such as Krishna. Despite the greater immediacy of television documentaries, news bulletins, and the Internet, paintings continue to be effective in expanding our visual world and consciousness.

In the seventeenth century, the French Academy, run by Charles LeBrun, prescribed a hierarchy of genres of painting, with history paintings—those that portray a story from the past, whether real or apocryphal, such as Géricault's *Raft of the Medusa*—at the top. Both Daumier's and Wyeth's works shown here constitute a reinterpretation of these rules: The choice of subject matter, although relatively humble, becomes significant because it is elevated through the art of painting.

In *Young America*, the young man, astride his bike rather than a horse, is dwarfed by the vastness of the American landscape behind him. His hat references

▼ **Advice to a Young Artist**, Honoré Daumier, *1865/1868, oil on canvas, 16¼ x 13 in. (41.3 x 33 cm), National Gallery of Art, Washington, DC.*

a Wild West past, and the decorative ribbons attached to the handlebars conjure contemporary Harley-Davidson mythology. The tempo here is glide, not gallop. By contrast, Daumier invites us indoors to scrutinize a private exchange. The youth listens intently, his head cocked toward the bearded teacher on whom the light falls, highlighting his opinion of the work. Illuminated, too, is the portfolio of drawings in the young artist's hands, and behind, hanging above the glow of the somber russet red of the model's couch, the walls are covered in figurative paintings. This painting belonged to Corot, Daumier's loyal friend and patron.

▲ **Young America**, Andrew Wyeth, *1950, egg tempera on gessoed board. 32 1/2 x 45 1/3 in. (82.6 x 115.1 cm), Pennsylvania Academy of the Fine Arts, Philadelphia.*

The Crucifixion, with the Virgin and Saint John the Evangelist Mourning

Artist
Rogier van der Weyden

Date *c.1460*

Medium & Support
oil on panel

Measurements
71 x 73⅜ in.
(180.3 x 186.4 cm)

Location
Philadelphia Museum of Art

Christ on the cross was often represented in devotional painting between the fourteenth and the seventeenth centuries. On a human level, the image offers the powerful theme of the tragic loss of a son, and for Christians, it represents the murder of the son of God. The story was painted by masters from different parts of Europe—Rogier van der Weyden worked in Brussels and Matthias Grünewald, who in c.1515 painted an equally iconic and powerful *Crucifixion*, in Germany. Although at this period it was usual for such a scene to be painted in a triptych, Van der Weyden's composition spans two panels, so it is rare structurally as well as being an utterly remarkable artistic tour de force.

The essence of the piece lies in the juxtaposition of powerful narrative and the minimal, meditative way in which the story is presented. The diptych format combines with the color scheme to create a level of restraint that gives the painting its gravitas. The two portrait panels work together to form a large square with balancing parts. In the left panel, St John supports the Virgin as she collapses; together the two grief-stricken figures form a curved, downward-sliding arc. The skull in the right panel represents the fragility of human life. The physical scale, the blocks of active color, and the tragic tale the picture tells all engulf the viewer.

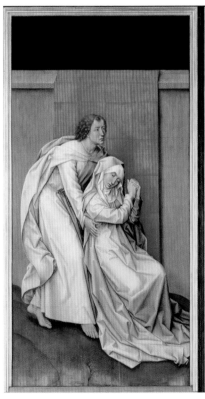
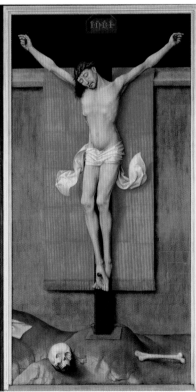

The Crucifixion, with the Virgin and Saint John the Evangelist Mourning

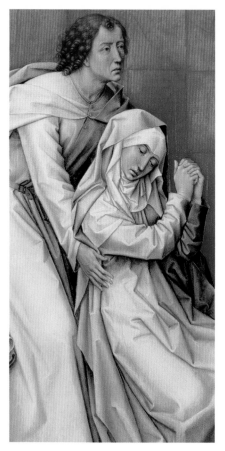

◄ Grief-stricken figures

St John looks over at the dead Christ while supporting the Virgin. Both figures are dressed in pale clothes, signifying mourning, but the Virgin's mantle is blue, as is traditional in Christian iconography, symbolizing both truth and heaven. Contrasting with the subtle colors of their skin and garments, the vivid red used for the cloth backdrops that frame the protagonists was commonly used in Renaissance paintings.

▲ Flowing drapes

The painting space is shallow, condensing the area within which the action unfolds. The drapes of the weeping Virgin spill over into Christ's panel, linking them and reinforcing the connection between mother and son.

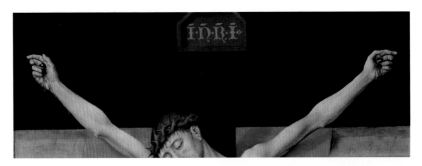

▲ On the cross

Behind the cross the wall is solid black. Christ's bloodied hands and arms extend into the darkness, connecting him to the cross and to the sign, often shown in images of the Crucifixion, that reads INRI (an abbreviation of the Latin phrase, "Jesus of Nazareth, King of the Jews"), which indicates he is straddling this world and the next.

▲ Loincloth

Van der Weyden painted the loincloth fluttering upward, perhaps to suggest Christ's spirit rising heavenward, signifying the moment of death. His body is elongated and his skin has a yellowish tone.

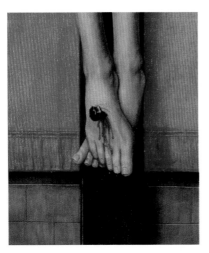

◀ Light and shadow

The red paint here is emotive, highlighting the blood and playing an important part in framing the subjects and giving shape to the story being told. Carefully delineated gray bricks support the cloth-of-honor backdrops with their precisely folded patterning. The light creates a shadow between the drapes and the wall, and shadows also enhance the visual play between the fringe and Christ's toes.

The Hunt in the Forest

Artist
Paolo Uccello

Date *c. 1470*

Medium & Support
oil on panel

Measurements
25⅜ x 65 in.
(65 x 165 cm)

Location
Ashmolean Museum,
Oxford

This brilliantly constructed painting is a highly
original composition by a master of mathematical
perspective. Hunting was a popular pastime of wealthy
patrons during the Renaissance, and this unusually
sized work may have been commissioned as a wall
hanging or the back of a bench to grace the entrance
to a patron's home. As a pioneer of perspective
incorporating mathematical techniques, Uccello fixes
a central vanishing point by using the decreasing sizes
of trees and the path of the river to create a sense of
depth. Decorative and animated, the scene conveys

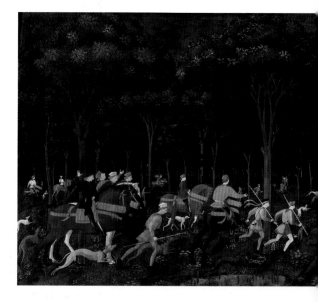

motion and energy. The huntsmen converge from each side, while the dogs and their prey disappear toward the center, drawing our eyes in. The somber background offsets the strong colors that spark and shout across the horizontal span of the panorama, suggesting movement, while the vanishing point of the perspective leads our eyes into the darkness of the forest. The use of bright, clear reds is interpreted as representing passion, and the hunt may also be read as the pursuit of love. These and other arresting details add to the visual commotion of this magical, likely imaginary, nocturnal scene.

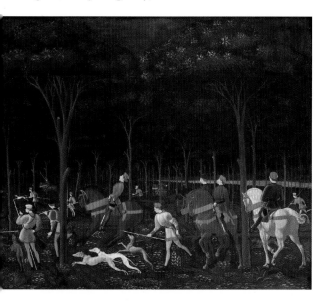

The Hunt in the Forest

◀▲ Elaborate accoutrements
Each individual has his own accoutrements:
Look at the range of horns, daggers and
scabbards, swords, gold and embroidered
waistbands, hats, spurs, fur, and gloves.
We can note details among them such as
the hat with the flying headband ribbon,
or the ermine, which is worn only by
the nobility.

▶ Controlling the hounds
The pale bodies of the excited
hounds, like the white batons
held by the men who control
them, pick up the light, and
each posture and expression is
different, legs straining, hands
gesturing, caught in silhouette
against the dark backdrop.

▶ Delicate foliage

Traces of the grid Uccello used to map out his perspectival design remain on the panel. The delicate foliage was originally speckled with real gold, creating a magical shimmering effect under a crescent moon, the symbol of Diana, the Roman goddess of hunting. The crescent shape is repeated on the horse trappings.

◀ Vanishing point of perspective

The sleek greyhounds and the deer appear to hop and dance in unison, the subtle shades of their coats shifting as they seemingly skip in and out of the darkness. They gradually diminish in size as they disappear into the gloom, funneled into the vanishing point. The trees have been cut to allow the huntsmen to pass easily, and the fallen trunks are also aligned in perspective, pointing diagonally into the picture plane. Unlike the animals, though, the men appear to pause, aware perhaps of the unknown mysteries in the depths of the forest, represented by the vanishing point in the center of the scene.

Venus with a Mirror

Artist
Titian

Date *c.1555*

Medium & Support
oil on canvas

Measurements
*49 x 41½ in.
(124.5 x 105.5 cm)*

Location
*National Gallery of Art,
Washington, DC*

Titian is viewed as a universal master in art, comparable to Shakespeare in literature in terms of the breadth of his influence and fame. His facility spanned religious, mythological, and portrait works. Supported by the most illustrious contemporaries, his fame was international, and his style matured over the course of a long life of painting.

Venus, the goddess of love and beauty, is here portrayed as a ravishing blonde, her hair tamed in coils, entwined with pearls, and crowned with a golden diadem. Her pose is based on that of a classical statue belonging to the Medici family. Titian kept the original painting in his studio until his death, either because he had a fondness for it or, as it was one of his most popular compositions (there are 15 examples), because he used it for copies. He has used various devices to control the way the viewer observes the painting. Our eye is drawn to Venus's face which, in comparison to the rest of her form, is in sharp focus and keenly detailed. The strong diagonal composition—running from the top of the mirror and across the expanse of her soft, pale belly, which glows against the dark, rich detail of the cloth that conceals her modesty—also encourages us to observe the elements of image in a prescribed sequence before taking in the extraordinary textures and rich colors of the composition as a whole. Her two playful companions lend a cheery air, making the sexy scene frothy and light.

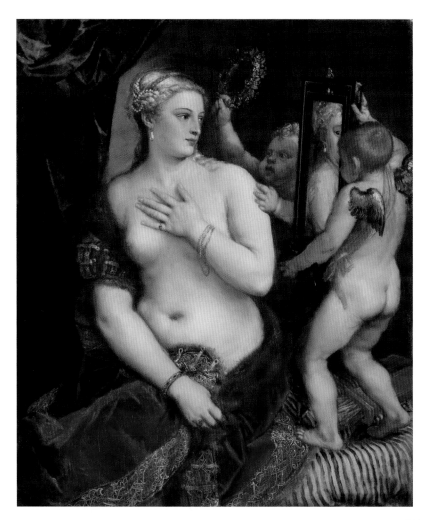

Venus with a Mirror

◀ Renaissance beauty
Painted using small strokes, Venus's face and blushing cheek offer a perfect complexion. Venetian painter Marco Boschini observed in 1674 how Titian would blend the transition from highlights to half-tones with his hand, merging one tint with another with a smear of his finger.

▶ Fallen quiver
Paintings of Venus often portray her accompanied by Cupid, her son. He was the god of erotic love, and whoever he shot with his arrow was filled with uncontrollable desire. Here, the arrows lie boxed and ignored on the bed while Venus commands the putti's entire attention.

◀ Reflecting beauty
The ruse of this work is the glass mirror (mirrored glass was a recent Venetian invention, and one that the poet Petrarch refers to as his "rival"). Venus looks into it, astonishing herself with her own beauty, and we see another view caught in its reflection. Venus's left eye holds our gaze, highlighted with a blob of lead white paint that matches the baroque pearl in her ear and makes another visual link to the smaller pearls entwined in her hair.

▶ Naked bosom
The splayed fingers of the goddess's left hand are arranged to draw attention to her perfectly formed, domed breast and her elegant neck. Here, Titian introduces a variety of brush strokes to add a wealth of texture, softening the contours of Venus's body. The gold chain wrapped around her wrist echoes the curved shape of her breast. The highlight on the ring draws attention to her nipple.

◀ Fur-trimmed wrap
Venus wears more jewelry than clothes, although she modestly pulls her fur-trimmed brocade wrap around her naked lower body. However, this gesture has the opposite effect of enhancing her sexuality by drawing attention to the soft pillow of her belly and enticing the viewer to see the rounded furry edge of the wrap, which suggests her pubic hair. The scene is intense, focused, and rich, its subject rendered as pin-up—a Marilyn Monroe for the sixteenth century.

Before and *After*

Artist
William Hogarth

Date *1731*

Medium & Support
oil on canvas

Measurements
Before
14¹/₃ x 17¹/₃ in.
(37.2 x 44.7 cm)
After
14¹/₃ x 17⁴/₅ in.
(37.2 x 45.1 cm)

Location
Fitzwilliam Museum,
Cambridge

We have Hogarth to thank for the Engravers' Copyright Act, passed in 1735 and known as Hogarth's Act. His serial moral tales were so popular when translated from paint to print that they were also much plagiarized, and he was among the first to lobby for original work to be respected and paid for when reproduced.

Hogarth liked to inject humor into his narratives, and his six-part tales, such as *The Rake's Progress*, are like cinematic tableaux. He also enjoyed pointing out the fragility of human nature and the grisly consequences of bad behaviour. This concise diptych tells an old story, recalling an eighteenth-century

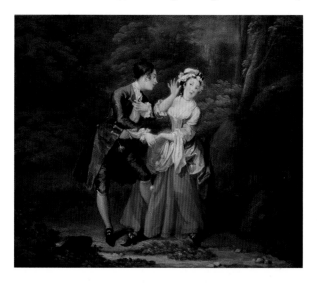

French tradition for depicting pastoral seduction. Known as the outdoor version (an "indoor version" is in the Getty Collection), it is on record as having been "ordered by Mr. Thomson," who was such a rascal himself that he had to leave the country and never collected the work.

In the first piece, these country folk are flirting. The apples in the young woman's apron offer a clue to the slippery slope of their mutual attentions, recalling the apple given to Adam by Eve, with disastrous consequences. The couple stand, she to the right and he to the left. In the second piece, their positions are reversed, and they appear disheveled after the sexual act. The apples, together with a discarded white garment, lie around them on the ground.

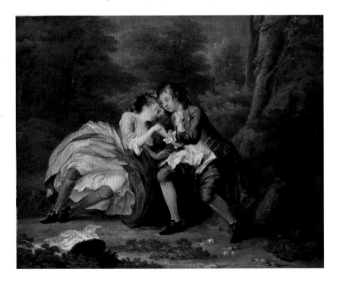

Before and *After*

▶ Seduction

The play of their hands is synchronized. He holds her left hand in his right, while she backs away slightly, her right hand open and raised, indicating surprise. He reassures her, pointing to his breast as if to say, "You need not fear me," and leans into her space. The fluted material of their white cuffs along with the blue and red of their respective sleeves are mirrored and parallel.

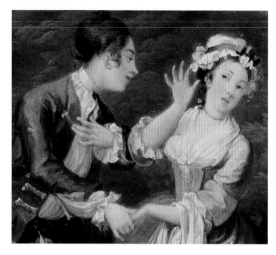

◀ Persuasion

Her apron has apples falling out of it, a sure sign that she, too, is an apple ready to be plucked, with her pert little bosoms, sweet red cheeks, and bright lips. One apple is seen falling alongside his leg, which is already pushing between her thighs. The red of her draped skirts encloses his white-covered leg in a manner that is very naughtily suggestive of a vagina enclosing a penis.

◄ Full-blown rose
In *After*, the atmosphere of
the secluded glade remains
unchanged, but now the
figures cling together. We
see the pale flesh of her
parted thighs, with her
red garters still holding up
the blue stockings as if to
suggest the haste with which
they have been laid bare.
The layered folds of her skirts
resemble the petals of a rose,
with the accompanying
message that she has
been deflowered.

▶ An undignified event
The seducer is spent but still
clutches the woman's hand
almost as if it is keeping him
upright. His shirt is falling
out over his undone trousers
and his pink penis hangs limp
and forlorn. We sense Hogarth
smiling while at the same time
pointing a judgmental finger.
All the dance of symmetry and
echo is disjointed and upset.
The scene is no longer a scene
of playful flirtation but one of
bewilderment and disarray.

Ophelia

Artist
Sir John Everett Millais

Date *1851–2*

Medium & Support
oil on canvas

Measurements
30 x 44 in.
(76.2 x 111.8 cm)

Location
Tate Gallery, London

This glowing Pre-Raphaelite image crystallizes a particular atmosphere and remains popular with those starting out on the journey of art appreciation: The postcard of this painting is the most purchased in the bookstore of the Tate, where the work resides.

It shows the death by drowning of Ophelia, a character from Shakespeare's *Hamlet*: the play tells us she drowned in the "glassy stream" of the "weeping brook." The subject was popular in the nineteenth century; in Millais's version it is also a portrait of Elizabeth Siddal, a model much used by the Pre-Raphaelites, who was later to marry Millais's friend Rossetti.

The painting is astonishingly and obsessively detailed in the sharpest colors. The acid green is vivid against Ophelia's boat-shaped body, and is repeated in the frame and echoed by the willow bough. Her clothes bear her up, the water filling the heavy fabric that will eventually pull her down to death. Her head is tilted back, her eyes and mouth open, and her hands are making an open, almost welcoming gesture as they break the surface of the water. *Ophelia* is simultaneously evocative and beautiful in its meticulous detail and horrifying in the ominous scenario it shows.

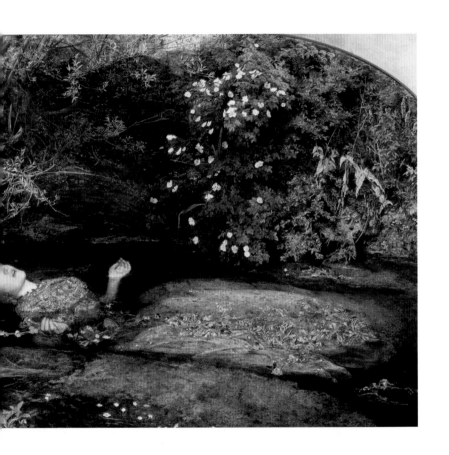

Ophelia

◀ **Mirrored surface**
The background was painstakingly painted on location, by the Hogsmill River in Surrey, England. The sharp shadows of the reeds enhance the way that we read the layering of what is above and below the surface of the water. This painting is about being semi-submerged, and Ophelia's hands breaking through the water's surface are the key to this perception.

▶ **The dress bore her up**
In March 1852, Millais writes to Thomas Combe, his friend and patron, describing Ophelia's "ancient dress all flowered over in silver embroidery," which cost him £4/$6.50 to have made (equivalent to £120/$195 today). In November of the same year, while painting outdoors to complete the background, he wrote, "We have had little straw huts built, which protect us somewhat from the wind, and therein till to-day have courageously braved the weather."

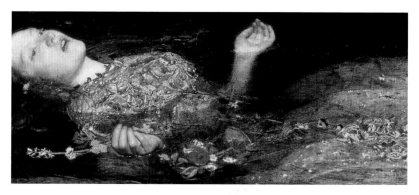

▲ Floating flowers
Each flower in the picture has its own symbolism. The poppy represents death, the daisy purity and innocence, pansies stand for thoughts, violets for faithfulness, and the forget-me-not is self-explanatory. The rose refers to the speech of Ophelia's brother, Laertes, who calls her the "rose of May."

▲ Skull in the foliage
On the bank to the right, a pale ovoid form suggests a skull with dark eye and mouth sockets, a reference both to Ophelia's fate and to the most famous scene in *Hamlet*.

▲ A watching robin
The robin may refer to Ophelia's snatch of song, "For bonny sweet Robin is all my joy," in Act IV of the play. Many Pre-Raphaelite painters found inspiration in Shakespeare.

The Horse Fair

Artist
Rosa Bonheur

Date *1853–5*

Medium & Support
oil on canvas

Measurements
*96¼ x 199½ in.
(244.5 x 506.7 cm)*

Location
*Metropolitan Museum
of Art, New York*

Bonheur was born to a family of artists in Bordeaux. In this huge painting she gives us a cinemascope view of a horse fair in Paris. Seeing it occupying an entire wall of the museum, we still feel the impact the work made on its first showing in 1855.

The work is a maelstrom of activity, the piercing sunlight falling on the three white horses that dominate the middle section, where the main action takes place. We see a black stallion rearing, sparking off a response in the horse beside it, whose wrangler struggles to restrain it. Control of chaos is the underlying theme, and the all-male cast are flexing muscles, raising whips, struggling with bridles, or riding bareback in the flurry.

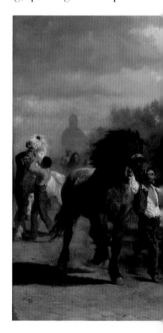

Bonheur was obliged to wear men's clothes in order to remain unnoticed on location while she made her preparatory studies for the scene.

Like most of the figures in the painting, she wore the standard French worker's blue drill dress, the *bleu de travail*. The same worker's clothes are seen in the finished picture as a current of cerulean, which runs through the scene from the blue duo, one in high-waisted trousers, on the left, over to the figure on horseback on the far right. Bonheur has included herself in the scene in male disguise—she is the central figure looking at us from behind the rearing white horse.

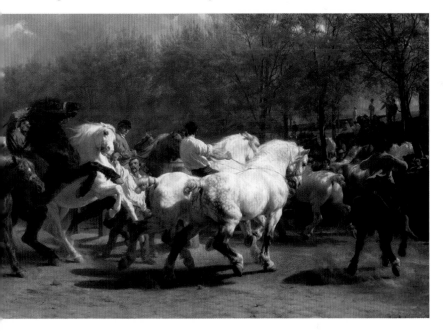

The Horse Fair

▶ Sky-colored rumps

Two dapple-gray rumps are highlighted by strong light from the left. The horses' tails are rolled in tight coils, underpinning the notion of man's control over animal.

◀ Raw physicality

The bare-chested man on the left is keeping a watchful eye on the commotion and making sure that his horse stays calm. The physicality of the scene is overpowering.

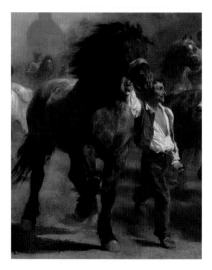

▶ Thundering hooves

You can almost hear the thudding of the hooves on the cobbles. The horses' shadows emphasize the little clouds of straw and dust as they rise in a reponsive flurry. Bonheur has created an exact replica of the ground's texture, with clods of paint and opaque color spread with a palette knife. The ambition and scale of her work preempts that of much later specialists in texture, such as Anselm Kiefer.

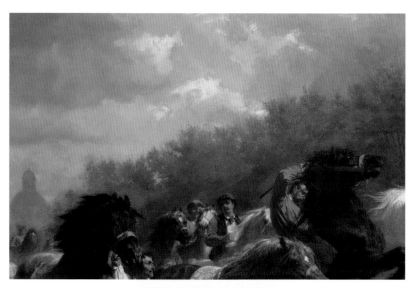

▲ Sweeping treeline
Around the action, the scene has a clear topography. We recognise the cupola of the Pitié Salpêtrière Hospital on the left, and the perspectival sweep across the painting is enhanced by the line of trees that begins as a blur and changes gradually into individually painted branches as it gets closer to us.

◀ Watching from a distance
Under the nearest trees it is calmer, and people watch the scene from the bank, safe from the scrum but able to enjoy the view, like us. It is interesting that all this massed and testosterone-fuelled equine and human energy was conceived and painted by a woman—and it brought her international fame.

The Artist's Studio

Artist
Gustave Courbet

Date *1854–5*

Medium & Support
oil on canvas

Measurements
142 x 235⅖ in.
(361 x 598 cm)

Location
Musée d'Orsay, Paris

Courbet's self-portrait portrays all human life as he sees it, with the artist center stage acting as an orchestrating ringmaster. The title clarifies his intention for the painting, and the life-size figures determine the scale. A canvas of this vast size had to be made from three separate pieces sewn together, a three-foot horizontal band a quarter of the way down from the top and a similarly sized strip along the left edge that bisects the head of the hunter. The "empty" space created by these extra pieces is important for compositional balance. Without the additional height and width, the figures would appear too squashed within the picture frame. That Courbet conceived such a huge work indicates his ambition, as well as the confidence and ego he needed to succeed in stating the case for Realism in painting, simultaneously portraying ordinary folk and the artistic elite. Individually, all the protagonists in *The Artist's Studio* are true to life, but their simultaneous presence is a construct. The painting was rejected for display at the 1855 Exposition Universelle, causing Courbet to finance his own "Pavilion of Realism" to

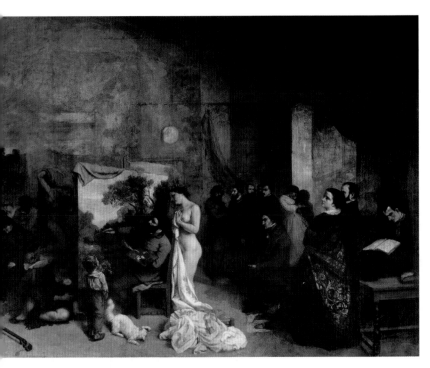

show both this and *A Burial at Ornans* (1849–50), another of his large, contested works, so that the public could decide for themselves. Today it is hard to believe that this work caused a furor when first shown, but it was one of the first representations of the proletariat in French painting.

The Artist's Studio

◀ Charles Baudelaire

The Artist's Studio is a contemporary updating of Ingres's *Apotheosis of Homer*, painted in 1827 and shown in the Louvre, in which Homer is depicted accepting the homage of all the great men of his time. Courbet substitutes himself for Homer, posing in profile, with his admirers recreating the scenario of classical deity surrounded by acolytes. One of those, Baudelaire, seen here holding a book, commented, "People will have their work cut out to judge the picture—they must just do their best."

▶ Champfleury

Courbet wrote to the critic Champfleury (depicted on the stool to the right), "It's the whole world coming to me to be painted... On the right, all the shareholders, by that I mean friends, fellow workers, art lovers. On the left is the other world of everyday life, the masses, wretchedness, poverty, wealth, the exploited and the exploiters, people who make a living from death."

Courbet's manifesto declares:

"Painting is a concrete art and can only consist of the representation of real and existing things. It is a completely physical language, the words of which consist of all visible objects; an object which is abstract not visible; non-existent, is not within the realm of painting."

This complex, provocative work criticized Emperor Napoleon III by implication, placing him, in allegorical form, on the left-hand side with the criminals. But Delacroix praised the painting in his journal, *"I stayed there alone for nearly an hour, and found his rejected picture to be a masterpiece; I could not tear myself away from it."*

▲ **Monsieur Bertin**

Courbet shows us he is familiar with traditional painting but that he wants to expand the visual debate. He references Ingres's painting of Monsieur Bertin (*see p64*) and also vanitas work (*see p33*) by including a skull in his composition.

◀ **Artist's muse**

The model poses as the painter's muse, one boy stands admiringly by, while another, off picture, is hard at work on a drawing. As Courbet orchestrates his world, the white cat plays carelessly at his feet. The critic Linda Nochlin wrote of Courbet, "He would never paint an angel, as he would argue that he had never seen one."

The Brighton Pierrots

Artist
Walter Sickert

Date *1915*

Medium & Support
oil on canvas

Measurements
25 x 30 in.
(63.5 x 76.2 cm)

Location
Ashmolean Museum,
Oxford

Like Uccello (*see p137*), Sickert uses formal perspective lines as the architecture for his complicated scene. The stage pillars are a strong visual element, together with the receding wooden boards and the shadowy side of the stage that we view head on. A pink ramp descends from promenade to beach, fringed by a green balustrade that separates it from the villas with their fluted fronts. All these elements literally set the stage. The players have their backs to the sea, and the sparse audience is ensconced on stripy deck chairs facing them, wearing an assortment of hats, typical for the time. Close to us at the lower right-hand corner is a sleepy fellow with a flat cap. Sickert's signature in black is to his left.

Sickert told his artist friend Ethel Sands that he went to watch and draw these entertainers every night for five weeks while staying in Brighton in 1915. He sold the finished painting to her younger brother as soon as it was completed, and was subsequently commissioned to paint another version, which is now in the Tate. Like his hero Whistler, to whom he had been apprenticed, Sickert was controversial, avant-garde, and a Francophile. He introduced the ideas and techniques of the French Impressionists to British artists, and later pioneered the use of newspaper photographs in his portraits and compositions.

The Brighton Pierrots

◀▼ Setting the stage

Modern electric lights flood the stage,
creating the performance space, and
in the buildings opposite we see the
lights are on too. The tone and tint
values of the pillars are used to signify
the lighting on the stage. Similarly, the
ceiling and floor planks are delineated
in black and pale gray respectively,
emphasizing the perspectival space
in relation to the ramp.

◀ Painting technique

Sickert uses thick paint as shorthand to
communicate the effect of stage lighting,
and the sense of his speedy, active brush
is all over the painting. Despite the
warm pink and the implied jollity, the
atmosphere of the scene is nonetheless
redolent of failure, leaving a shoddy,
forlorn, and down-at-heel impression.
The row of deck chairs echoes the
stripes of the makeshift stage, the candy
stripes of the pillars, and the houses in
the background.

A pierrette wearing a white ruff, a pink hat, and a dress with polka dots turns to us as she plays the piano. Her companion pierrot, in a full jumpsuit of vivid green with a ruff and a cone-shaped hat, is seated, a drum at his feet. The two figures are framed by the pink-and-blue garlanded pillars that bisect the stage.

◀ **Compositional triangle**

Two of the troupe wear boaters, and their suits are the same pink tone as the ramp and the sunset-infused sky. At the center of the work, looking at us through the gap left by the lifted leg of the nearest performer, is a hawker with a tray of refreshments. The high kick of the performer creates a triangular shape that frames the hawker; he in turn echoes this triangle with arms that carry the tray of goods. Sickert highlights the performer's inner leg with pale pink to draw our attention to the hawker, who he deftly describes in quick dabs of black, suggesting a real character in bursts of paint.

New York

NARRATIVE

Artist
George Bellows

Date *1911*

Medium & Support
oil on canvas

Measurements
42 x 60 in.
(106.7 x 152.4 cm)

Location
National Gallery of Art,
Washington, DC

Bellows moved to New York from Ohio in 1904, and became a leader of the Ashcan School of American realism. Like his contemporary Edward Hopper (*see p168*), he was keen on the burgeoning artform of cinema, and also had a strong interest in music and dance too.

Bellows interprets the life of the city, manufacturing a composite version of midtown Manhattan by gathering many different but recognizable elements together in a single work, in a similar way to the northern British paintings of L. S. Lowry.

Both artists show a profound appreciation of people, whom they portray in great numbers against the dense city mass. They use small details in brief brushstrokes to evoke instant characters and scenarios. Here, the New York skyline is different from the smoking chimneys of Manchester, but the tall skyscrapers are grouped in a similar military formation, penning in the workers as they dash to their appointments and jobs.

Three clear horizontal bands form the compositional structure of the painting, encasing the swooping verticals. The foreground strip has people with

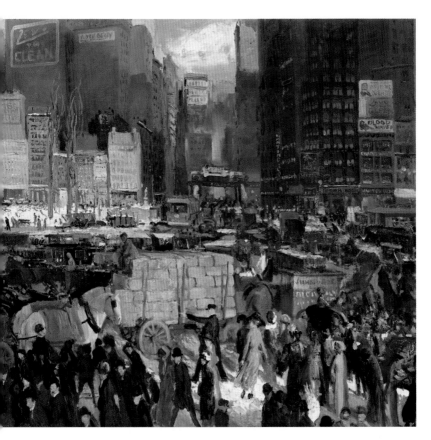

discernable features and characteristics. The horse-
drawn cart marks the edge of the next section, along
with a trolley bus loaded with passengers. As things
become smaller in the distance, and the tree outlines
coax our eyes into looking upward, we notice the high-
line train above the road.

New York

▶ **Bold colors**

As the foreground breaks into light and color, a woman in a long blue coat and another in startling red can be picked out of the crowd. Skillful brushstrokes indicate that the first figure is turning on her heel, the actual swish of her coat suggested in paint, her shoes black against the snow.

◀ **Significant figures**

People flow from all sides— to our left is a man in a raincoat and a trilby hat, to his right a gray bearded man in a top hat passes, and behind him we see a sidewalk sweeper in a white uniform. In the center is a man who looks straight out at us, to his right a policeman has his arm outstretched, pointing. All these figures are distinctive and individual, created with a few skilled brushstrokes.

▶ Advertising hoardings

The graphics of the advertisements on the sides of the buildings emphasize individual branding amid the masses and reinforce the impression of the busy city, adding further to the visual bustle. White, smutty smoke rises from roofs, mixing with the steamy atmosphere in the distance and fudging the landmarks into a haze.

◀ Best seat in the house

Center stage is a man atop a beige boxed load—the city equivalent of hay bales. He has the best seat in the house, as he is able to survey the whole scene. Another cart crosses in front of him, with two white horses facing him, pulling their own load. On the left we spy a bowler-hatted man hanging onto the end of the bus while others try to cram inside.

New York Movie

Artist
Edward Hopper

Date *1939*

Medium & Support
oil on canvas

Measurements
32¼ x 40⅛ in.
(81.9 x 101.9 cm)

Location
Museum of Modern Art,
New York

By the time he reached his 40s, Hopper had developed a distinctive method of working. He would make drawings of his subject in situ—for this work alone there were 52 of them—then create his highly stylized paintings back in the studio. Each of his paintings is diligently recorded in his notebooks, where he methodically noted technical details: "Winton canvas, Winsor & Newton colors—1st lead white and linseed oil. 2nd zinc white and poppy oil. N.Y. Movie House. 32 x 40 Jan 29, 39 finished."

There were four local cinemas near Hopper's apartment in Washington Square North, Greenwich Village, where he lived for 54 years, and he loved to visit them. This work has a similar film-noir, claustrophobic, and melancholy atmosphere to that of his famous painting *Nighthawks* (1942). The painting is split into two parts: on the left, dreams are offered to the seated audience; on the right, the usherette looks pensive and bored. She stands behind the bars of the brass handrails while others indulge their fantasies from well-sprung red-velour seats. At this time the cinema was still a people's palace, and here, painted stucco decorations adorn the walls and three globes of light glow, suspended under the balcony.

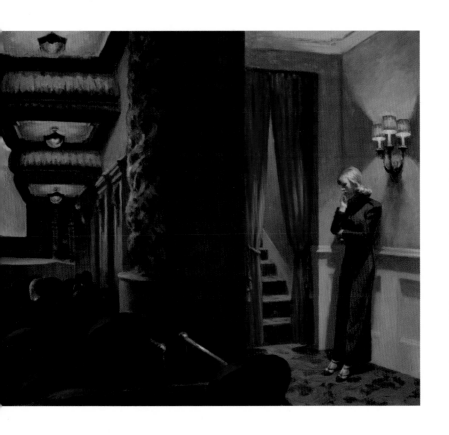

New York Movie

▶ **Work and play**

The pensive, uniformed usherette has her head in her hand, in a detail reminiscent of Auguste Rodin's *Thinker (Le Penseur)*. She leans against the wall, clutching her flashlight. Contemporary photographs show that Hopper made a truthful depiction of the interior of the Palace Theater, and a 1937 article in the *New York Post* also pictured the military-style uniform worn by its usherettes. They were not allowed to watch the films while on duty, explaining her look of boredom and reverie. Her blond hair glows under the triple crown of red-shaded lights.

▲ **T-bar shoes**

The detail of her T-bar shoes is minutely recorded. The red-curtained staircase suggests freedom from the wall-to-wall gray patterned carpet of her prescribed place: She is rooted in inaction.

▶ Lighting

In his ledger, Hopper describes this painting underneath a crosshatched black ink drawing of it. He notes the colors as garnet and the "dull blue carpet, figured" with a "dull white on the screen (snowy mountain tops)," and "light from four sources, brightest point on girl's hair and glint on rail." The painting is all about light: the projected light of the film, the light of her flashlight used to show people to their seats, and the lights in the ceiling and on the wall behind her.

◀ Dreams

The year Hopper finished this painting also saw the release of *Gone with the Wind* and *The Wizard of Oz*. He said, "I go to the movies for a week or more. I go on a regular movie binge." Films offer an alternative reality, and here the painter gives us a view of an engaged and disaffected audience: three isolated figures all held in stasis for the duration of the film fantasy. Hopper's wife, Jo, posed for the figures in the audience and the usherette.

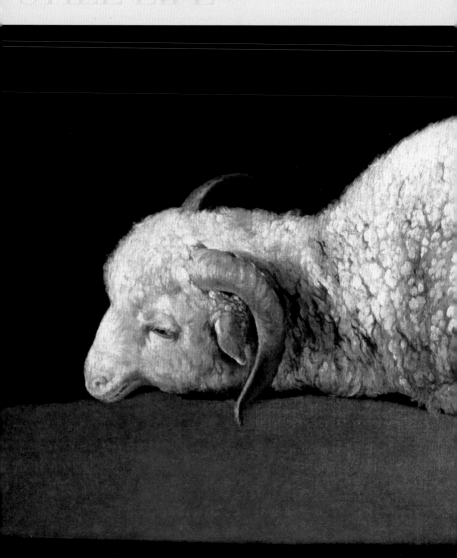

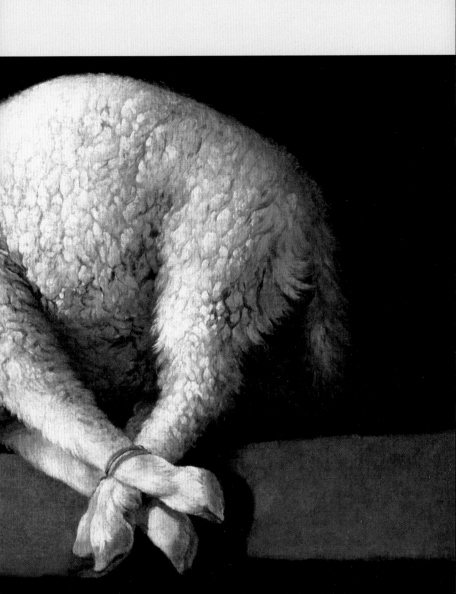

Still Life

Western still-life painting focuses on both natural and manmade objects, often in combination—a way of celebrating and recomposing the beauty of the natural world. In the case of vanitas works (*see p33*), luxury items feature too, with a focus on consumerism. Inanimate objects are often augmented by small living things, such as insects or butterflies, and these details also advertise artistic skill. *Nature morte* was the term first used in eighteenth-century France to describe this genre.

"It's always nature and truth; you feel like taking the bottles by their nozzles if you are thirsty; the fish and grapes whet the appetite," critic and philosopher Diderot wrote of the work of Chardin. The artist often used a stone shelf to display his magical renderings of the simple things in life—in this work, he includes some sparklingly fresh mackerel, curly-rooted radish, and freshly baked gougères.

Although Zurbarán's painting is unconventional for

▶ **Agnus Dei**, Francisco de Zurbarán, *1635–40, oil on linen, 14³⁄₄ x 24²⁄₅ in. (37.3 x 62 cm), Prado Museum, Madrid.*

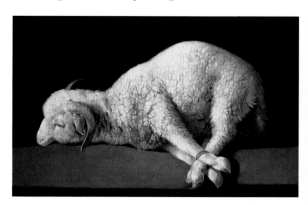

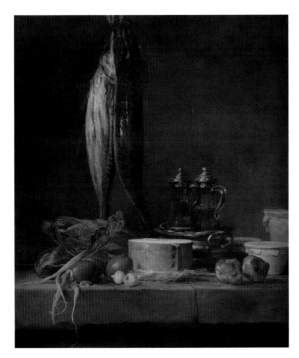

◀ **Still Life with Fish, Vegetables, Gougères, Pots, and Cruets on a Table**, Jean-Siméon Chardin, *1769, oil on canvas, 27 x 23 in. (68.6 x 58.4 cm), J. Paul Getty Museum, Los Angeles.*

the genre, it can be considered a still life as it objectifies and isolates the lamb, offering it up for our intense consideration. Trussed up and ready for slaughter, the vulnerable lamb was a common subject in the seventeenth century, and alludes to the sacrificial death of Christ. We notice how the matting of the fur reveals the shape of the body. Like Chardin, Zurbarán has used gray to offset his subject. The light comes sharply from the left, creating a chiaroscuro with the intensity of the white animal against the black background, supine on the sacrificial gray slab.

Panaches de Mer, Lithophytes et Coquilles

Artist
Anne Vallayer-Coster

Date *1769*

Medium & Support
oil on canvas

Measurements
51¹⁄₅ x 38¹⁄₅ in.
(130 x 97 cm)

Location
Louvre, Paris

Vallayer-Coster was 25 years old when she painted this *tour de force* of underwater treasure. Both her parents were artists, and she was recognized early on as an artistic prodigy. Like her contemporary Vigée-LeBrun, she was admitted into the highly prestigious Academy, one of only four women members at the time. As a Royalist, her career was advanced by the favor of Marie Antoinette, although this proved disadvantageous after the French Revolution. Her work sold to both those at court and the merchant classes, all of whom were attracted to her ability to create the illusion of still-life objects with seamless technical ability.

This painting was accepted for exhibition by the Salon in 1771. The arrangement is organized as if the shells and coral were sprigs and bunches of flowers. These objects from the sea are the marine equivalents of other popular subjects for still life, such as fruit and flowers, dead game, birds, or hares. The shells are collectible and, furthermore, exotic. They come from distant lands overseas and, along with their pure beauty, carry a hint of mystery, perhaps even of danger.

The objects need somewhere to sit within the picture, and the wall here seems inspired by Chardin (*see p175*). The gray-toned craggy surface fits the visual resonances of the sea hoard perfectly.

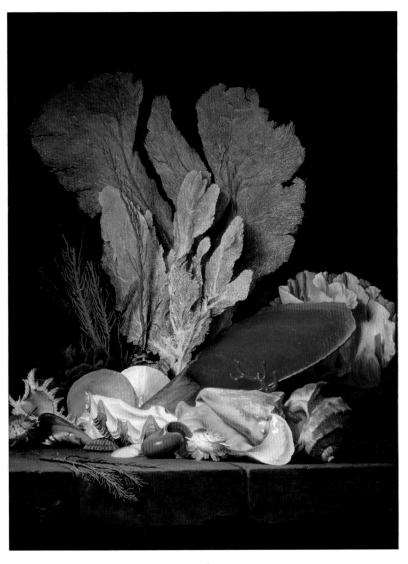

Panaches de Mer, Lithophytes et Coquilles

▶ Repeated verticals

The central section focuses on vertical coral reds with some mauve touches, both standing above the whiter fan coral. Some sponges are shown behind on the right. The large shell, propped diagonally, is also tipped with nacre, shown to great effect next to the clear white clam. The selection of reds used in the middle ground plays a significant part in holding our attention and focusing it on the marvelous range of painterly effects. These textures are so particular and detailed that they truly conjure the specific varieties of corals and shells.

◀ Perspectival arrangement

Vallayer-Coster concentrates on the spaces within the shells: the bowl of the clam, and the deep, sexual pink of the conch with its glistening sheen. To emphasize the perspective within the work and the suggested distance between the viewer and the foreground, she has introduced a small frond of purple coral hanging diagonally over the edge of the wooden support.

▶ **Fan-shaped corals**

The composition is dominated by the pale mauve fan coral, which acts as both background and backbone to the whole display. This and the lighter pieces are silhouetted against the dark backdrop, adding drama to the composition.

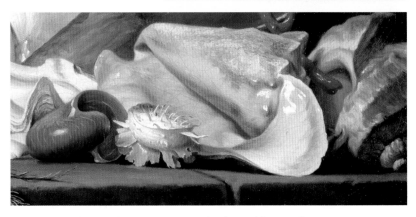

▲ **Luscious pink enamel**

The pearly pinks and blues are most impressive. The artist's skill in suggesting these complex colors is remarkable, and it is no wonder she was elected to the Academy with a unanimous vote from her peers. The layered enamel smoothness of some pieces here is tempered by the spiky shells, which change the tempo of the work.

Still Life with Bread, Ham, Cheese, and Vegetables

Artist
Luis Meléndez

Date *c.1772*

Medium & Support
oil on canvas

Measurements
24⅜ x 33½ in.
(61.9 x 85.1 cm)

Location
Museum of Fine Arts,
Boston

Meléndez was the greatest still-life painter in eighteenth-century Spain. He trained as a portrait painter, but bad luck meant that he turned to the less prestigious *bodegón* (literally, a pantry or wine cellar and its contents) for his subjects, and it eventually became his métier. In 1771 the Prince of Asturias (later Charles IV) commissioned him to paint a series of works of "every species of food produced by the Spanish climate." When completed they were hung together, creating a dazzling concentration of glowing texture in detailed images of food and kitchen equipment. His paintings give us a glimpse into contemporary kitchens and larders—and the opportunity to see how little culinary taste has altered over time.

Meléndez's technical wizardry makes it easy to believe these delicious morsels are really there. Here, he has prepared a rustic but mouthwatering picnic for us. All the different elements are arranged on a piece of thick wood, the horizontal lines of its grain running parallel with the bottom of the canvas and small nicks apparent on the outer edge. The light falls from the left, highlighting the glaze of the pitcher and the gleam of the glass bottle, and creating shadows that add to the three-dimensionality of the piece. This is a masterly spread.

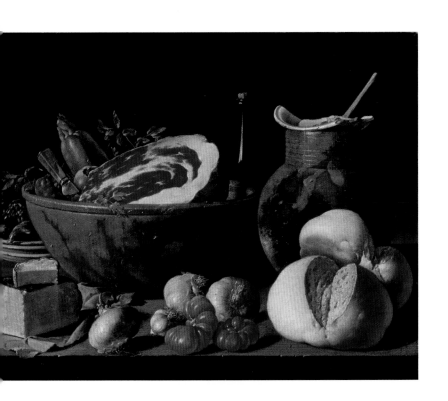

Still Life with Bread, Ham, Cheese, and Vegetables

▶ Marbled effect

The ham is dry-cured jamón, darkly succulent with marbled cherry-red flesh and a glistening, fatty rim. It sits perfectly within a round bowl that enhances its shape and displays Meléndez's skill in conveying volume and texture. The glinting knife plunges into the meat at an angle, catching the light.

◀ Baker's mark

The manchego cheese has just been unwrapped from its white cotton cloth. The two-tone pale gold of the textured wedge is encased in black wax. The crunchy outer crust of the fresh bread reveals the baker's mark —that clean split through the dough that helps ensure an even bake. The two breads, one angled against the other, have a perfectly smooth outer shell and a wholesome inner section. They invite us to break them easily open into two shareable halves. The number of repeated elements within this composition almost adds to the flavor that is the game of discovery of the constituent parts.

Harmonious colors and shapes

Stuffed into the bowl behind the ham are a zucchini, a sausage, and some parsley—with just enough greenery to balance the other colors. The artist summons up the deep flavor of the ripe figs by setting off their green and purple ovoids on white tin-glazed plates, the color and shape of which are echoed by the touch of white in the broken crock that serves as pitcher lid. Plates, bowl, and pitcher form a trio of robust utensils, hand-thrown with a shiny, mottled glaze.

▼ Red for attention

Small white onions, one with a bright green shoot, and plump, misshapen red beefsteak tomatoes are deliberately placed centrally to inject visual punch.

Bunch of Asparagus

Artist
Édouard Manet

Date *1880*

Medium & Support
oil on canvas

Measurements
*18¹/₁₆ x 21⁵/₈ in.
(46 x 55 cm)*

Location
*Wallraf-Richartz-
Museum, Cologne*

Manet's work forms an artistic bridge between the Realism of artists such as Courbet and the Impressionists. He famously "updated" the Renaissance works *Pastoral Concert* and *Venus*, by Giorgione and Titian respectively, transforming them into *Le Déjeuner sur l'herbe* and *Olympia*, causing a great stir and resulting in his rejection from the Academy. His avant-garde and inspirational paintings were shown instead at the Salon des Refusés, the alternative space for non-traditional artists. The problem was the unconventional way in which Manet used naked women in his compositions. Rather than using the acceptable customary Classical settings, his "picnic painting" portrayed them accompanied by clothed men in an open, sylvan setting.

Outrage often seems to help artistic careers, but only if the individual has talent. Manet's ability to conjure life with oil on canvas is vibrant even when dealing with humble vegetables, such as his bunch of asparagus, presented larger than life without plate or board. During the 1880s he produced several small works concentrating on a few elements and sent these display exercises as gifts to friends. His artistic heroes were the old masters, in particular Velázquez: ironic, considering Manet's reputation as a Modernist. He is known as a "painter's painter."

Bunch of Asparagus

◀ **White on white**

The dense, stumpy spears are bound in two golden hoops of gardener's twine, securing them as they sit, slightly tilted like a rocking boat on a green sea of luscious fronds. There are touches of lemon yellow and blue merging with the overall viridian to enliven the surface. The cleverly shadowed background moves from dark on the left through a green brown to a honeyed brown on the right. This merging of shadow creates a curved environment for what seems like a vegetable balancing act.

▶ **True to nature**
Seventeenth-century Dutch still-life artists also employed dark backgrounds to enhance the tints and tones of the objects in focus. The subtle interplay between the mauve tips, the grays, and pasty whites creates a color relationship between the horizontals of the asparagus and the surface on which it rests. Confident brushstrokes bestow individuality on the tightly bunched spears.

► **Fluidity**
Manet paints freely and, it seems, with pleasure. The work appears spontaneous: a vehicle for displaying his abilities with the loaded liquid brush. In response to the painting, contemporary writer and critic Georges Bataille wrote, "This is not a still-life like the others, although still, it is, at the same time, lively."

◄ **Asparagus,**
Edouard Manet, 1890,
oil on canvas,
16.5 x 21.5 cm
(6¹/₂ x 8¹/₂ in.),
Musée d'Orsay, Paris.
Collector Charles Ephrussi bought *Bunch of Asparagus* for 800 francs, but sent Manet 1,000 francs for it instead. In an elegant gesture, Manet painted this single white spear, and sent it to Ephrussi with a note: "There was one missing from your bunch."

187

Still Life with Pansies

Artist
Henri Fantin-Latour

Date *1874*

Medium & Support
oil on canvas

Measurements
18½ x 22¼ in.
(47 x 56.5 cm)

Location
Metropolitan Museum
of Art, New York

Fantin-Latour celebrates a modest, everyday plant taken from the greenhouse, still in its clay pot. Some of the flowers have already been transferred to a display basket. Apples picked straight from the tree lie alongside, and all the elements are given a detailed, portrait-like treatment. The composition has three clusters of activity—two clay pots, basket, and apples—arranged on a rounded-edged table. The sunny yellow pansy grabs our attention first, inviting our eyes to investigate from the middle outward. The darker, blue-black pansies are to the right and in shadow; the challenge for the painter is how to convey their deep, velvety sheen—like black tulips, these blooms have their own aura. Latour portrays them in a trio, like a row of faces. Their purple-black petals almost merge with the uniform deep gray of the background, but remain tonally distinct.

Latour's wife, Victoria Dubourg, was an independently successful painter and an avid gardener. In 1874, she listed 31 of his compositions of flowers and fruit, including this one. The couple excelled at still-life painting, and both were members of the Parisian artistic circle of the 1860s, which also included Manet, Degas, and Morisot.

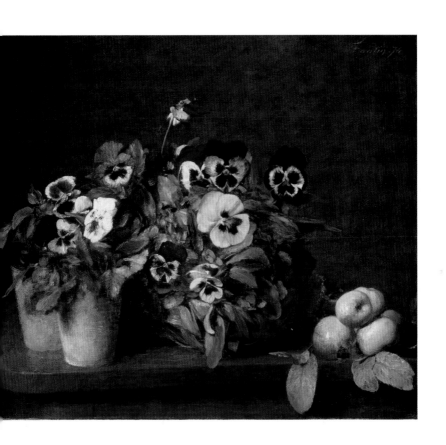

Still Life with Pansies

▶ **Contrasting textures**
The sap-green apples contrast with the pansies; they are tart, sharp, and rosy, against the softly bunched fronds of the pansies' glossy viridian leaves. Their smooth texture is painted with longer strokes, displaying the adept handling of paint. Here, the oil paint feels almost like watercolor, while elsewhere in the picture it has been used in messy, runny blobs.

◀ **Individual flowers**
The French for pansy is *la pensée*, also meaning thought. Fantin-Latour's paintings of all varieties of flower are always thoughtful; he seems to characterize them perfectly. Painter Jacques-Emile Blanche wrote of him, "Fantin studied each flower, each petal, its grain, its tissue as if it were a human face. In Fantin's flowers, the drawing is large and beautiful; it is always pure and incisive... It is an individual flower and not simply one of a type."

◄ Thoughtful observation
In the front of the first pot is a lone flower painted sideways with its face turned away from the observer. The brushstrokes have been applied to the petals carefully, conveying the subtleties of the color changes within them, and here we can understand the skill of the artist's observation, and sense his delight in the way the pansies resemble nodding heads.

▶ Garden fruit
Fantin-Latour was in the habit of painting subjects freshly plucked from the garden, and chose to use these five apples in the composition still attached to the knobbly branch. Their inviting rosy glow picks up a highlight of white paint where the skin catches the light, while the leaves are misshapen, textured, mottled, and spotted with rust.

Mound of Butter

Artist
Antoine Vollon

Date *1875–85*

Medium & Support
oil on canvas

Measurements
19¾ x 24 in.
(50.2 x 61 cm)

Location *National Gallery of Art, Washington, DC*

Vollon's painting is an ode to butter and to the color yellow. We feel the joy the artist experienced when describing the translucent viscosity of this marvelous natural product. Vollon's unusual idea for a still life grasps our attention with its purpose and singularity. Butter is like oily paint, and he offers us an artistic palindrome in which butter and paint are somehow in equal balance. The choice and isolation of a specific subject matter also has a Pop Art quality in that it raises the humble and the mundane to a level of serious consideration.

Like Hogarth, Vollon was first apprenticed to an engraver. After studying in his hometown of Lyon he went to Paris, where he befriended Daumier and Daubigny. He was considered a master of Realism, dubbed, like Manet, a "painter's painter" and hailed as the Chardin of the nineteenth century. Emile Zola called him a "virtuoso of the palette," but his hopes of working in the more esteemed sector of figure painting were dashed by Manet's negative comments. Many artists who are successful in one particular area of their practice suffer from being pigeonholed, but Vollon's magical butter is destined to occupy the same space in art as Proust's madeleines do in literature.

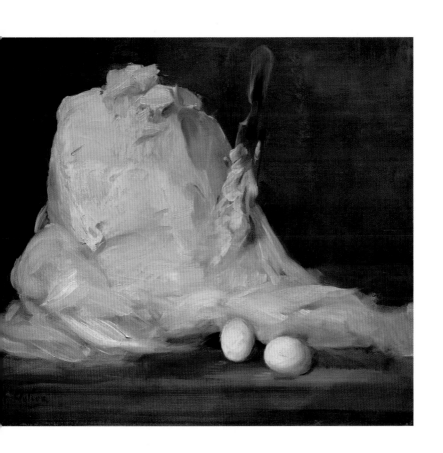

Mound of Butter

◀ **Yellow, white, and brown**
The wooden spatula-like knife stands upright, rooted in this compact mass. A pentimento to its left indicates the position in which it was first painted, and a ghostly outline remains where the artist changed his mind. Around the base of the mound, like a fallen skirt, is the white muslin in which the butter was originally wrapped. There is a reflected buttery highlight on the brown edge of the knife. The butter that clings to the base of the knife is distinctive, painted differently and in smaller strokes, setting it apart and at an angle from the central mass of pallid, textured flatness.

▶ **Ovals**
This is fresh country butter from a churn, piled high and solid, not the automatically packed sticks we are familiar with today. Two white eggs are positioned in the muslin, one vertical and one horizontal. Their shells have a chalky, tactile surface and offer a further display of Vollon's painterly prowess. These two immediately recognizable shapes in the foreground provide an elegant and simple scale measurement—we can surmise that this is a very large pile of butter indeed. That one egg is vertical and the other horizontal makes them seem more active, about to topple over in contrast to the very stable, solid mini-mountain that is the unveiled butter.

◄ Casual fluidity
Like many still-life paintings, this quiet drama operates from a horizontal base, as if it were a stage. Here, the lighting is full on the central character, the butter, made prominent by the nuanced black-gray of the background, darkest on the left. The bravura brushstrokes of the butter mound itself seem casual, and the technique recalls Sargent's fluid ease.

► Sculptural quality
Although the painting seems modest, its effect is to help us see the butter as something sculptural, shaped and coaxed into a pale heap of fat that slides and glistens. Under the muslin to the left of the baseboard is another ghostly shape, where the artist changed the painting as he worked. The work is signed "A. Vollon," using a smaller brush, and underlined in black.

Japonaiserie:
Flowering Plum Tree

Artist
Vincent Van Gogh

Date *1887*

Medium & Support
oil on canvas

Measurements
21¾ x 18 in.
(55 x 46 cm)

Location
Van Gogh Museum,
Amsterdam

This unusual work confounds our general perceptions of Van Gogh, illustrating his ability to break through conventions and celebrate the compositional importance of the Japanese print. His is a very close reinterpretation of the great Japanese printmaker Hiroshige's *The Plum Orchard in Kameido*, mimicking printmaking techniques of cropping and gradation of color. Both this and *Bridge in the Rain*, also painted in 1887, just before Van Gogh left Paris for Arles, were copies of works in Hiroshige's *One Hundred Views of Edo* (numbers 30 and 58, respectively).

The arrival of cherry blossoms is a special time in Japan, and this work shows how the artist responds to cultural manifestations through pictures and without words, appreciating the purely graphic quality of the texts he cannot read. In 1854 Japan had resumed international trade after 200 years of isolation and *Japonisme* became fashionable, particularly after the Exposition Universelle held in Paris in 1867. Van Gogh admired Japanese art, saying it was "as simple as breathing; they draw a figure with a couple of strokes with such an unfailing easiness as if it were as easy as buttoning one's waistcoat." In Van Gogh's *The Starry Night* (1889), it is clear that he has redeployed the shapes in Hokusai's famous print *The Great Wave* to inform the patterns in the sky.

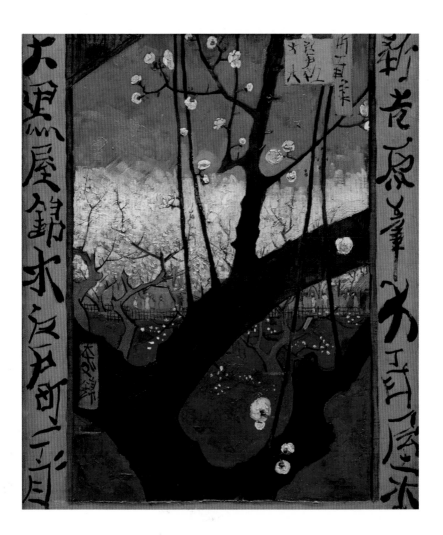

Japonaiserie:
Flowering Plum Tree

▶ **Japanese inspiration**
Van Gogh possessed a large collection of Japanese prints; he was attracted to the flatness of color and the boldness of design. Artists are often inspired to replicate artworks, as a practical method of sorting out visual problems, and a way to pay homage to a master. Van Gogh copied works by artists ranging from Doré to Delacroix.

◀ **Mix of colors**
Van Gogh changes the pink of Hiroshige's original to orange, and shifts away from viridian green to a tone that matches the off-white blossoms rather than the original clear white. The use of black to outline the trees in the middle distance links them to the mainstay of the composition: the split tree trunk that operates like a huge anchor. This use of black as a dramatic force within the painting resonates powerfully with that of Beckmann (*see p37*).

▶ Main branch

The dominant foreground branch is replicated in the Japanese calligraphic lines and holds the entire structure of the work. This famous tree was called the *Garyubai* ("Reclining Dragon"); its branches traveled underground and re-emerged to form new trees. The orchard itself was named "The Scented Refuge of Purity."

◀ Composition

Van Gogh maintains the bright, contrasting, circular shapes of the individual blossoms as they stand out from the darkness of the branches. These and, to a lesser extent, the other spots of flowers in the background give the painting a lively dynamic, jostling visually with the outlined trunks in the middle distance, echoed in black lettering. The tree structures dominate the composition, forming a pattern that refers to the elegant Japanese characters that both flank the piece and occur within it.

Venus Rising from the Sea
—A Deception

Artist
Raphaelle Peale

Date *c. 1822*

Medium & Support
oil on canvas

Measurements
29¼ x 24⅛ in.
(74.3 x 61.3 cm)

Location *Nelson-Atkins Museum of Art, Kansas City*

Peale's father, Charles Wilson Peale, was a successful artist who opened the first art gallery in Philadelphia in 1782, and helped found the Academy of Fine Arts there in 1805. He was a Renaissance man and a portraitist, famously including a real step and a door jamb in a trompe l'oeil depiction of his sons. He named his children after artists: among them Rembrandt, Rubens, Titian, Ramsay, Rosalba, and Raphaelle, whose own trompe l'oeil work here is witty and suggestive.

At first glance we see a hanging white cloth suspended from a tape. The clear folds give us an indication of the scale of the cloth, and their strict lines animate and divide up the entire section of canvas that would otherwise read as a blank space. It is a space with visual purpose, reminiscent of the cloth of honor traditionally shown painted behind images of the Virgin (*see p133*). However, the cloth is the deception in the title. It's a visual pun, covering the painting and obscuring the body of Venus—all we can see is an arm, a hand, some hair, and a foot. This draws our attention to the power of the picture and the potential of censorship.

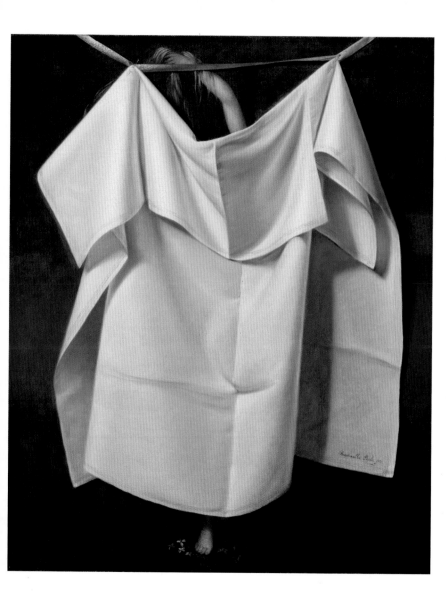

Venus Rising from the Sea —A Deception

▶ **Behind the drape**
Peale's painted drape here enhances the secretive, erotic aspect of the work —it plays with understood codes of painting, yet remains a sexual tease. Venus's hair in golden strands is caught up in her hands in what is both a provocative and realistic fashion.

◀ **Provocative tension**
Peale, a still-life painter, offers us a tight focus within the painting's space. In both this and the dark background, he references the work of seventeenth-century Spanish artist Cotán. By hiding the artwork and focusing on the lack of context and the formal qualities of folded cloth, he appears to be ducking the issue of portraying Venus. The cloth is a substitute for the subtleties of the body; here the crease could equate to the folds of flesh and skin. Countering this sensation is the tension evoked by the fiercely observed pin as it pierces the cloth that creates a makeshift barrier between us and the woman, and secures it to the tape.

▶ Barrier

Courbet's risqué painting of 1866, *L'Origine du Monde*, which showed explicit female genitalia, was originally concealed behind real curtains, and drapes are used to cover paintings in studios. The cloth is a barrier, separating the picture plane, and is the raison d'être of the work—a deception, hiding a painting of a woman. But it also prefigures white abstract paintings such as those of Manzoni (*see p17*), while simultaneously acknowledging the crisply ironed tablecloth, that mainstay of still-life painting.

◀ Hidden signature

An additional, smartly deceptive illusion is the artist's signature written as if it is an identification tag on the cloth, and underlined by three parallel red decorative lines that add an extra dimension to the play of the folded pattern. The deep shadows accentuate the illusory three-dimensional quality and "veracity" of the cloth.

Still Life

Artist
Giorgio Morandi

Date *1950*

Medium & Support
oil on canvas

Measurements
14¹/₈ x 18⁵/₈ in.
(35.9 x 47.3 cm)

Location
The Phillips Collection,
Washington, DC

Morandi recycled the same set of vessels from his Bologna studio into different configurations over many years. This serene work employs his "standard" elements. The arrangements never feel random, as if he has just put the pieces down; we always have the sense that he has spent time arranging and readjusting them, revealing the relationships between the different shapes. His paintings are like groupings of old friends and family—not always easy bedfellows, but polite and patient together. Morandi knows his subjects well. The spatial dynamics he invents shows them squeezed and compressed as if under physical pressure. One might expect the enamel metal pitcher to shine, but as in the rest of the work, the paint is muted and matte. The whole has a dreamy, poetic sensibility.

The artist's signature, a capital "M" with characteristic curls on either side, is subtle and hardly visible against the pale gray-brown ground. At the extreme edges of the painting, traces of bare, unpainted canvas remind us he is creating an illusion. Never a painter of large works, Morandi seduces us by stealth, creating discreet paintings with a limited palette, which speak in a gently modulated whisper.

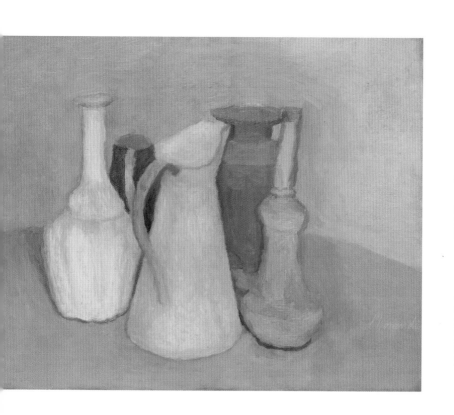

Still Life

▶ **Thin-necked vase**

Two whitish vessels glow, dominating the piece. The thin-necked vase splays outward into a fluted double-bulbed form, and casts a short shadow that intensifies the white. Light gray shadows and rounded brushmarks that echo those in darker gray at its base tell us that the vase is fluted. Although initially we see these colors as a closely linked group, the closer we look, the more we can analyze the variety of subtle tints and tones within the group.

◀ **Enamel pitcher**

The pale grayish-white enamel pitcher with a white interior stands in the middle of the canvas. The brushstrokes follow the shadows around the lip and under the handle, gradually turning brown and slipping anonymously into a third jug, which is placed with its back to us. The interior of this smaller jug is a light, opaque taupe.

▶ Trio of color

Two vases secure the right side of the work with color. The pale pink seems to hover, wobbling, next to a light brick red. Their necks form a window of space and their rims kiss. Level at the top, they make a trio with the pitcher rim. The paint nudges along the base of the pink vessel, and the shifting gray shadows are stopped short, underlined by a darker brown.

◀ Pink vase

At the lower right side of the pink vase, the shadow seeps at one point into the color of the round table on which it sits. Around the objects the color is subtly nuanced. The edge of the table is distinct, just barely sharper on the darker left side. There are no lines within this work to differentiate the different forms. These objects appear because of the nuances of paint that Morandi employs, engaging our eyes with what seems to be a magical trick.

Cake

Artist
Wayne Thiebaud

Date *1963*

Medium & Support
oil on canvas on panel

Measurements
5 x 8⅔ in.
(12.7 x 21.9 cm)

Location *Philadelphia Museum of Art*

Thiebaud's art deals with traditional painting issues of composition, light, color, and scale. He presents us with a single humble piece of cake. Creating a semblance of a slice takes skill, and he makes us very aware of the different types of brushmarks used to create the illusion.

Thiebaud acknowledges that he "loves art history," so we can surmise that he is familiar with many kinds of still-life painting. Here, he expands the genre by offering us a slice of a contemporary-looking cake finished with a shop-bought maraschino cherry. Painted from memory, his works challenge us to distinguish between painting done from life and his own "coded memory shorthand" reiterating his impression of an object. In this way, Thiebaud questions the illusory nature of painting. Psychologists have confirmed that our visual memory retains simple structures and exaggerates distinguishing characteristics. Looking at this cake, a viewer might principally remember its square form and the red cherry. In other paintings, Thiebaud often repeats recognizable motifs—individual cakes, for example—

in serried ranks, comparing like with like and thus
emphasizing their minute differences. In this single
dissected cake he concentrates on the forms—the
circle, the triangle, and the rectangle. The subject looks
as edible as Meléndez's picnic (*see p181*), yet somehow
more jolly and contemporary.

Cake

◀ **Textures**
The paint is luscious, applied with a palette knife for a smooth background around the cake, but changing to vertically applied brushstrokes to the right. The ridges made by the stiff hogshair brush are visible, as is the canvas texture where it is thinly painted. Talking about white, Thiebaud said it is composed of all colors, absorbing and reflecting them.

▶ **Cherry on top**
The cake is like a little square house, compact and insular, pert on its perfectly round base that itself sits on a second circular base. The deep red-brown cherry sits atop it, complete with a glint of white highlight, with a pure ultramarine shadow alongside it. The paint appears analogous to the icing; the thickly smeared white background seems as solid as its dried crust. The ridges of the medium dry proud of the canvas in the same way. The pretense that this piece of cake is edible is pushed to the extreme.

▶ Shadowing

Thiebaud favors the same multi-colored shadows characteristic of the work of the Impressionists. Here, the blue edge is merged with white as he drags his brush along. He marries the blue with gentle tints of pink and lemon yellow, as well as hints of green and amber brown. The springy sponge of the cake mass is a pale ocher topped with pure smooth, white icing.

◀ Drawing on experience

The artist relates his brand of Pop Art painting to his experience of working in restaurants in his youth. He remembers "seeing rows of pies, or a tin of pie with a piece cut out of it and one piece sitting beside it. Those little vedute in fragmented circumstances were always poetic to me."

Still Life with Goldfish

Artist
Roy Lichtenstein

Date *1974*

Medium & Support
*oil and Magna
on canvas*

Measurements
*80 x 60 in.
(203.2 x 152.4 cm)*

Location *Philadelphia
Museum of Art*

In this self-conscious homage to Matisse, Lichtenstein mimics the elements of the latter's *Interior with Goldfish Bowl*—black-ink portrait drawing, goldfish in a transparent beaker, and the general composition, with buildings in the background and a curved wrought-iron balcony balustrade. Using black to outline important elements within the work can be dangerous, as black is a powerful visual tool (a similar strategy can be seen at work in Van Gogh's painting, *p196*). Here Lichtenstein parodies artistic formulae and injects a populist aesthetic while employing traditional methods and materials. Because the lines are straight and there is no overt painterly surface, the result reads like a diagram that has been filled in, leaving no breathing space. Only the tiny figure outline on ocher appears to differentiate from the claustrophobia of this tight sequence of rules made visible. Together with fellow Pop artists Jasper Johns, Andy Warhol, and James Rosenquist, Lichtenstein cemented a new way of looking at and making accessible art. Here, the viewer is presented with goldfish in a beaker, ironically updating the traditional lobster on a silver platter that was a popular subject in the seventeenth century.

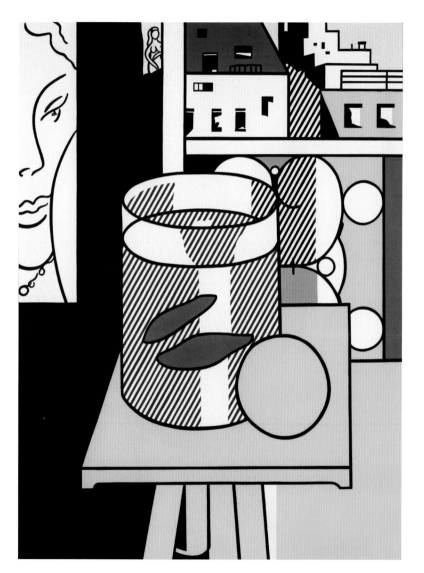

213

Still Life with Goldfish

▼ Water

Water is rendered in diagonal blue lines, while blocks of pure yellow dominate the foreground and link it to the houses beyond. Specifically scaled circles and geometric shapes enhance relative distances within the canvas. The primary colors are used in a stylized and deadpan graphic manner. The two red fish are balanced against the largest yellow orb, directly in line with the woman's slanted eye.

▲ Two women

The woman on the left is set apart behind the solid block of black, frivolous with curvy hair and a necklace of rounded droplets, her overt sensuality in contrast with the flat, hard-edged, comic-strip interpretation of Lichtenstein's Pop Art world. The other figure seems like a small sketch on cream-coloured paper, tacked to the wall as a reference to relative scale.

► **Black outlines**

The artist's black outlines convey a cartoon-like feel, the opposite of Vollon's bravura brushstrokes in painting his butter (*see p195*). This painting, by comparison, is flat and low key, yet this is still paint on canvas. Time separates these paintings, but love of the genre connects them. Shadows are created by repetitive black diagonals that speak more of T-shirts and packaging than the illusion of modulated shadow space.

◄ **Goldfish bowl**

Matisse painted a number of canvases that included goldfish in containers shaped like this. They are his equivalent to the red spot Corot uses in his silver-gray landscapes to enliven the surface of the painting and focus attention on a particular area. Reusing the fish emblem is like deploying a favorite toy in the game of composition.

Abstraction

Abstraction

▶ **Untitled Number 5**,
Agnes Martin, *1975,
acrylic and graphite on
canvas, 60 x 60⅕ in.
(152.5 x 152.8 cm)
Museum of Modern Art,
New York.*

▼ **192 Colours**, Gerhard
Richter, *1966, oil on
canvas, 78¾ x 59 in.
(200 x 150 cm) Hamburger
Kunsthalle, Hamburg.*

Abstract paintings may not have instantly immediate content, but they take form through recognizable brushstrokes and techniques. The accepted canon relates that Kazimir Malevich, Piet Mondrian, Wassily Kandinsky, and Hilma af Klint created the first non-representational works at the turn of the twentieth century. Dispensing with an actual subject was a breakthrough for painting and gave artists free rein to experiment without the necessity for imitation.

Kandinsky recounted his epiphany when he saw Monet's painting of haystacks and did not recognize them, thus realizing that a painting without objects could exist. Mondrian analyzed and fractured his vision of a tree with dogmatic persistence, eventually transforming it into pure, flat colors. Af Klint believed the spirit world guided her innovative abstract compositions, making her paintings meeting points between art, life, and religion.

Richter's paint serves as both subject and object. The gloss paint refers to Pollock, while the cool minimalist grid displays the gamut of colors as if from a DIY paint shop. Martin's work uses pencil to outline form, measuring the flow of time in another fashion. Although she refuted the relationship of her painting to nature, here the vertical columns seem to shudder, not unlike the rising heat haze of the desert.

Nymphéas (Waterlilies)

Artist
Claude Monet

Date *1905*

Medium & Support
oil on canvas

Location
Musée de l'Orangérie, Paris

In 1909 Monet wrote that, together with his waterlily garden at Giverny, which was attended by no fewer than five gardeners, "These landscapes of water and reflection have become an obsession for me…" His very French *grand projet* was to translate the experience of this totally immersive environment onto long, thin, bowed canvases that would surround the viewer, mimicking real life. Both the garden and the paintings are still popular, and the environment for the painted panels at the Musée de l'Orangerie would today be called an installation. Monet left the paintings to the state, much as Joseph Turner had bequeathed his oeuvre. Both artists were aware of their important legacy to art, and both had been innovators with regard to the challenge of painting light and catching the nuanced atmospheres rendered by the effect of light on scenes.

These works are six feet six inches high and, if lined up side by side, would measure 299 feet. Sometimes Monet has incorporated the canvas joins into the

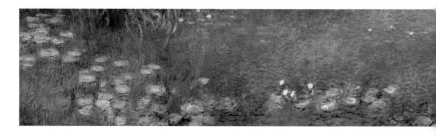

composition. There are a total of eight canvases displayed within two specially built oval rooms, four representing sunrise, and four dusk.

Monet wanted "the illusion of an endless whole ... a refuge of peaceable meditation in the center of a flowering aquarium." The reflected clouds are scumbled, misty pink confections lying on the surface of the painting. The palette runs a gamut from viridian green through apple tones, cerulean blue to indigo, pale mauve, pink, and deep purple like a wave of active, colored undulating space. The effect is cumulative, generous, and measured; there are no central highlights or main focus of attention, but instead quiet, meditative expanses.

The paintings hover and float, dream landscapes, mental adventures in perception into the realm of the senses. There is no mirrored sheen of glaze to augment the liquid depths; instead Monet uses layers of blunt, bumpy, chalky opacity, juxtaposing colors and surface pattern to share his water world.

"... a strange artistic spectacle: a dozen canvases placed in a circle on the floor, one beside the other, all about two metres wide and one metre twenty high; a panorama made up of water and lilies, of light and sky. In that infinitude, water and sky have neither beginning nor end. We seem to be present at one of the first hours in the birth of the world. It is mysterious, poetic, delightfully unreal; the sensation is strange; it is a comfort and a pleasure to see onself surrounded by water on all sides."

RENÉ GIMPEL,
ART DEALER AND PATRON, 1918

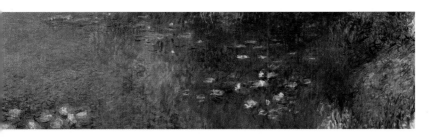

Untitled No. 22

Artist
Hilma af Klint

Date *1914–15*

Medium & Support
oil on canvas

Measurements
61 x 59⅘ in.
(155 x 152 cm)

Location
Gemeentemuseum
Den Haag, The Hague

▶ **Attitudes to abstract**
Artistic attitudes are
varied regarding what
Kandinsky called "the
spiritual in art," but
which Joan Mitchell
dismissed as "hokey."
Some held that abstract
art should inspire but
contain no reference
to the "soul." Artists
including Malevich,
Mondrian, František
Kupka, and af Klint all
came under the spell of
Theosophy, a philosophy
that proclaimed one
fundamental truth
and embraced the
writings of Blavatsky,
Steiner, and Jung in
the twentieth century.

Before she died, af Klint stipulated that her art should not
be exhibited for 20 years. She made automatic drawings
from 1896, and she was a leader of The Five, a group of
Stockholm artists who held strong mystical and
philosophical, as well as artistic beliefs.

Af Klint practiced as a medium and created non-
objective paintings, making a remarkable contribution to
the development of abstraction. By claiming spiritual
intervention in the production of her work, af Klint
expanded the primary concept of the abstract by removing
even herself from her art. Previously art was shackled to
the narrative of religion, but in af Klint's work, abstraction
becomes an echo of a meditative, trance-like state.

This geometric work shows two color wheels in
opposition, joined and separated by a diamond similarly
trapped within the "space sandwich" of the
outlined box. The image appears simultaneously flat and
three-dimensional. A textured, darker background color
is roughly painted above and below. The black lines
delineating the spaces vary in thickness, and cadmium
red is added on the central and the bisecting axes. The
painting is in two halves, but it has three dominant parts.
The work offers both chaos and control. It sets light and
color in opposition and precarious balance within the
claustrophobic confines of the painter's rectangular
illusory space. Mondrian used a linear structure to contain
his colors and, like him, af Klint created visual metaphors
that suggested an ordering of an inner spiritual evolution.

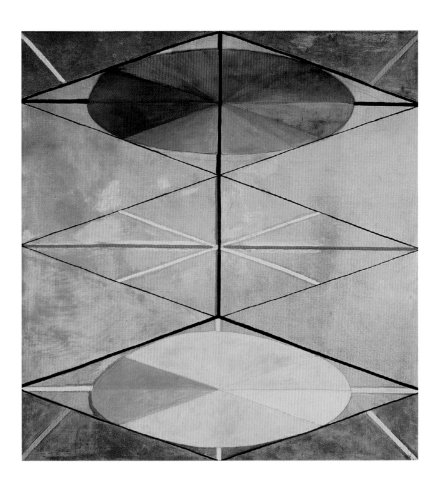

Océanie, le Ciel, Océanie, la Mer (Oceania, the Sky, Oceania, the Sea)

Artist
Henri Matisse

Date *1946*

Medium & Support
screenprints on linen

Measurements
66½ x 141⅓ in.
(169 x 359 cm)

Location
Musée Matisse,
Le Cateau-Cambrésis

We associate Matisse with vibrant, active color, but in these pieces the uniform pale ocher backdrop allows us to appreciate his innate feeling for pattern and his agility with the *découpages* (paper cutouts). Initially made as a decorative commission from textile printer Zika Ascher, they were the first cutouts Matisse made that were inspired by his visit to Tahiti. "There, swimming every day in the lagoon, I took such intense pleasure in contemplating the submarine world."

Matisse called his cutouts "painting with scissors"— the scissors establish the line, making the pencil and brush redundant. He dispenses with his usual jazzy palette and conducts the fluted clouds and the elements of the underwater world, suggesting impasto by collaging layers of shapes together. The seaweed waves, the octopus jiggles, and fronds of leaves complete the scene. We fill in the blue of sky and sea to complete these pictures for ourselves because we recognize the forms and the movement.

At first glance we read the images as symmetrical, but on closer inspection we realize they are not. The edges are distinctive—*La Mer* is framed with irregular seaweed patterning and contains the set of underwater-world shapes, while the same type of framing recurs in *Le Ciel*, but with birds and fronds dancing about inside. A central shape ressembles an oddly tethered, ghostly anemone, and fish have also swum up into the heavens. These works are sublimely confident. One can sense Matisse's enjoyment

"An artist must never be a prisoner of himself, prisoner of style, prisoner of reputation, prisoner of success."

JAZZ, HENRI MATISSE, 1947

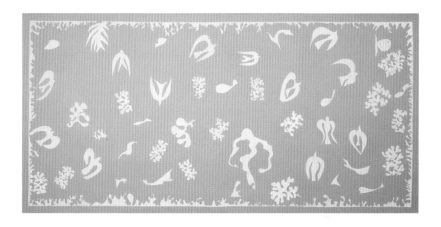

of the process and his delight in allowing the elements to juggle with one another, dancing to their own tune.

Matisse evolved the cutout technique and made it his own, saying "(it) constitutes my real self: free, liberated." Even today, despite the simplicity of form, it is instantly recognizable as his.

▲▲ **Océanie, le Ciel**
(Oceania, the Sky)

▲ **Océanie, la Mer**
(Oceania, the Sea)

Deux Femmes Courant sur la Plage (La Course)

Artist
Pablo Picasso

Date *1922*

Medium & Support
Gouache on plywood

Measurements
*12⁴/₅ x 16¹/₅ in.
(32.5 x 41.1 cm)*

Location
Musée Picasso, Paris

*"More than one
commentator has
already remarked
on the important
role autobiographical
content played in the
art of Picasso. His
private life constantly
showed through his
work, either directly
as, for example in the
portraits and in many
figures, or in a highly
allusive manner, and
where one would least
expect it."*

PICASSO IN RETROSPECT,
MICHEL LEIRIS, 1980

Picasso is one of the great names in twentieth-century art and despite his obsessive, relentless figuration is often considered to be an abstract painter. He made the essential elements of a scene plain for us, and showed how these could be refined to represent the essence of a subject, paring things down, "abstracting" their basic characteristics. This tiny work speaks of physicality, passion, complicity, and freedom.

Of course these women are recognizable as figures but they are "abstract" figures. They are transformed, resembling sculptures of giant classical goddesses racing along the sand. Picasso painted them while on holiday on the Côte d'Azur with his wife, Olga Kokhlova, a former dancer with the Ballets Russes. The surety of the line reflects his brilliant drawing skill, and the simplicity of color suggests the summer heat. Their ungainliness is the key to how we read the picture: rather than svelte, toned beauties, they appear as Amazons thundering down the beach, powerful and muscular. Swathed in Greco-Roman style, they seem to symbolize more than what we see (Picasso had visited Pompeii in 1917). They are personifications of freedom, abandon, and delight in the sun and the sea. The scudding clouds echo the forms of the drapery as it moves, in tune with the figures.

Picasso's genius is to suggest vast space on such a small scrap of paper. Holbein has been described as a master of "little and large," and the same is also true of Picasso.

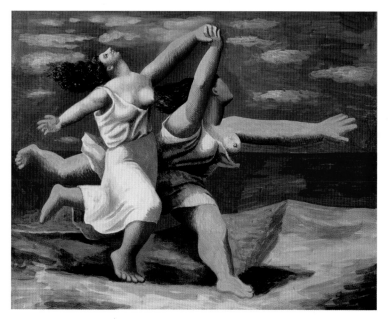

Serge Diaghilev, founder of the Ballets Russes, asked if the picture could be enlarged to make a front cloth for his ballet, *Le Train Bleu*, for which Coco Chanel had designed sporty rather than classical costumes. When the copy was completed, Picasso was delighted with it and wrote "Dédié à Diaghilev. Picasso 24" onto the huge canvas, indicating his approval.

Henry Moore said this image acted as a landmark in his youth and changed his life.

Bed

Artist
Robert Rauschenberg

Date *1955*

Medium & Support
oil and pencil on pillow, quilt and sheet on wood supports

Measurements
75⅓ x 31½ x 8 in. (191.1 x 80 x 20.3 cm)

Location
Museum of Modern Art, New York

"I also like seeing people using materials that one is not accustomed to seeing in art because I think that has a particular value. New materials have fresh associations of physical properties and qualities that have built into them the possibility of forcing you or helping you do something else."

INTERVIEW WITH
DOROTHY SECKLER.
21 DECEMBER 1965

Rauschenberg recycled his quilt in the first of what he called his "combines" and what Jasper Johns referred to as "painting playing the game of sculpture." The alternative canvas and stretcher support questions how paintings should look and how their method of construction affects their meaning. Influenced by the mass-produced "ready-mades" exhibited by Marcel Duchamp, Rauschenberg's materials, or *objets trouvés*, are more personal; this was his own bed cover, which he transformed into a kind of self-portrait. His desire to break free from traditional ways of making art emerged early—while serving in the Navy during the Second World War, he made a drawing with his own blood.

The bed is disconcertingly upright; our instinctive feeling is that beds should be horizontal and not soiled, so this transgressive form simultaneously fuels our curiosity and dismay, catapulting us into confusion and surprise. The work evokes Picasso's Cubist sculptures made from found materials and the Surrealist and Dada worlds of the unconscious "dreamscape." The cloth has been attacked and disfigured with aggressive pencil marks where a head should lie, and paint dribbles down the old-fashioned American quilt. It is an aggressive act of protest graffiti, infiltrating the quiet and symbolic space usually reserved for many of our private thoughts and activities. The sublimated dream space here demonstrates Rauschenberg's aspiration to force painting to relate both to art and to life, a revolutionary gesture that now looks relatively tired and tame.

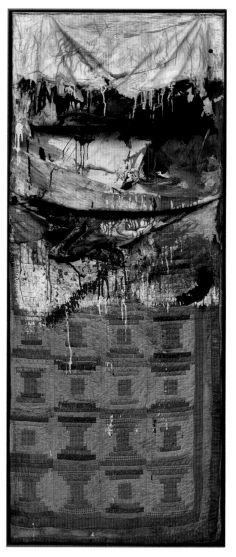

◄ Three-dimensional collage
Rauschenberg used real objects as
springboards for our imagination. He
did not attempt to re-create beauty,
but wished to distance himself from
Abstract Expressionism and to
formulate a new sort of artistic
dialogue. His desire was to "act in
the gap" between art and life. In
pursuit of this, he also worked with
the Merce Cunningham Dance
Company, designing stage sets,
performing, and choreographing.

Trojan Gates

Artist
Helen Frankenthaler

Date *1955*

Medium & Support
*oil and enamel
on canvas*

Measurements
*72 x 49 in.
(182.9 x 124.1 cm)*

Location
*Museum of Modern Art,
New York*

*"Upon this field [of
canvas] the physical
energies of the artist
operate in actual detail
...with no reference to
the exterior image or
environment ... It is the
physical reality of the
artist and his activity of
expressing it, united to
the spiritual reality of
the artist in a oneness
which has no need for
the mediation of
metaphor or symbol."*

JACKSON POLLOCK,
FRANK O'HARA, 1959

Titles are useful in art, particularly abstract art, as they can signal interpretations of a work. In Frankenthaler's work the titles emerge from the suggested shapes in her painting. Here, the gates can be seen in black and spliced between them we catch a kind of exuberant figure, arms outstretched, between the heavy forms. Below is a shape that could be the white specter of a horse. These imaginings are one way to see into this abstract piece, although even without a figurative interpretation we can experience the force of collision in the work, and this relates to the war in the title and the stalemate of exhaustion between the Trojans and the Greeks that characterized it. The Trojan War was a bitter conflict that started over beauty and possession and can be seen as having a conceptual link with the notion of ownership in the collection of art. These various strands of response are provoked by the title, and our imagination is spurred on by the action of the brush on the surface and within the fabric of the canvas.

Frankenthaler was first to employ a new technique of pooling paint heavily thinned with turpentine onto her canvas, which, like Jackson Pollock, she laid on the floor. This method permitted an alternative control of color, letting it seep into the raw canvas and spread in stained veils, imbuing the fabric with tint and hue. With this innovation, described as color-field painting, the infiltration of the canvas allows the pigment to resonate in a particularly powerful way.

"My life is square and bourgeois. I like calm and continuity. I never want to go on a safari. My safaris are all on the studio floor."

HELEN FRANKENTHALER

◀ **Spearheading**

The floodgates opened and artists such as Mark Rothko and Morris Louis also created large abstract works that pulsed with brooding color and still speak to us of spirituality and suggest mystical interpretations. The Abstract Expressionists had gained artistic dominance, and the center of the art world moved from Europe to America.

"What concerns me when I work," said Frankenthaler, "is not whether the picture is a landscape, or whether it's pastoral, or whether somebody will see a sunset in it. What concerns me is—did I make a beautiful picture?"

Montauk I

Artist
Willem de Kooning

Date *1969*

Medium & Support
oil on canvas

Measurements
88 x 77 in.
(223.5 x 195.6 cm)

Location
Wadsworth Atheneum,
Hartford

*"There is no difference
between the ocean
beach nearby and at
Montauk, but I have
an association because
I go there quite often.
Particularly in the
off-season, in the late
fall, or even in the
wintertime. It would
be hard for me now to
paint any other place
but here."*

INTERVIEW WITH
HAROLD ROSENBERG, 1972

De Kooning's solo New York exhibition in 1959 sold out. His avant-garde, subjective, and gestural paintwork had become an acceptable and popular brand, and younger artists were copying him. He commented dryly, "I'm selling my own image now."

De Kooning famously painted big, pink women with attitude, his brush swishing their skin, making them vibrate with sexual energy. In *Montauk I* he turns the same approach to his experience of Montauk, at the tip of Long Island, changing his subject from women to the sea. "There is something about being in touch with the sea that makes me feel good," he said in an interview with Harold Rosenberg in 1972. Looking carefully, we can still trace a disembodied pair of eyes, lopsided lips, and a strange limb in the pell-mell that is the roaring surface of this painting. The work is a real collision course of energetic action painting and dynamic juxtaposition of line, tone, color, and form.

De Kooning stowed away in the SS *Shelley* to New York from Holland in 1926, and his relationship with the sea lasted all his life. He observed "when the light hits the ocean there is a kind of gray light on the water." However, this painting seems more like a battleground, a vertical field of dragged pigment elbowing for room. It hums with activity and is made to be the receptacle and document of the artist's performance. In 1969, however, this style of Abstract Expressionist work was on the verge of death, soon to make way for Pop Art. Nonetheless, the painting persists as a representation of the dream of Modernism.

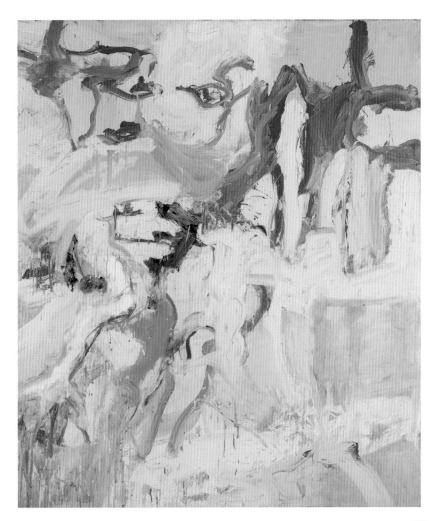

233

Salut Tom

Artist
Joan Mitchell

Date *1979*

Medium & Support
oil on canvas

Measurements
*111 x 316 in.
(282 x 802.6 cm)*

Location *Corcoran
Gallery of Art,
Washington, DC*

This perfectly proportioned set of four portrait panels was painted after the death of critic Tom Hess, who had championed both Mitchell and De Kooning (*see p232*). In French, *"Salut"* can mean both hello and good-bye.

Mitchell's art links Impressionism with Abstract Expressionism. Like Monet, she worked in series, and she focused on landscape, painting large canvases of her surroundings. This is an abstracted view of the Seine from her home in Vétheuil, France, where Monet also lived between 1878 and 1881, and where Mitchell was based from 1968. Painted some 50 years after he created his *Nymphéas*, Mitchell's *Salut Tom* is almost as long as Monet's vast work (*see p220*).

The cresting wave of lemon yellow creates a glorious, sunny backdrop and sustains the central band of white pigment which is cut and mixed with brilliant sap green, eau de nil, and the palest of ultramarine blues. The deep-blue-indigo-black patches operate like dark holes, swallowing up color while simultaneously enhancing it. Mitchell uses this black judiciously, like Matisse, in order to let the other colors sing at full

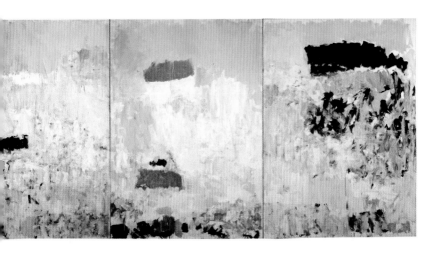

volume and the light to shine through. The panels operate in the same way as a framework of musical staves in sheet music, documenting rhythms within which the painting's heavy impasto and textural qualities can dance. The work appears light, airy, and joyous, celebrating rather than mourning death, making this painting distinctive and clever. In parts, globs of oil paint are slapped, thudding onto the canvas, while in other sections the paint appears both creamy and dense yet with a shine that seems still liquid and translucent. The mixtures of fresh greens and yellows jump with energy, full of the promise of spring and renewal.

▲ **Positive color**
Mitchell had several forms of synesthesia and often used music and poetry to propel her into creating her art, which she described as "a sort of scaffolding made of painting stretchers around a lot of colored chaos." The paint is a physical documentation of recalled mental states and feelings, and for her, the color of hope was yellow.

Everlasting Waterfall

Artist
Pat Steir

Date *1989*

Medium & Support
oil on canvas

Measurements
108½ x 95 in.
(275.6 x 241.3 cm)

Location
Brooklyn Museum of Art,
New York

▶ **Gravity**
In the online journal
The Brooklyn Rail, in
2011, rehearsing her
movement before she
throws the paint, Steir
comments "[I realized
that] I didn't have to
use the brush, that I
could simply pour the
paint, I could use nature
to paint a picture of
itself … that gravity
would paint my
painting with me."

Pat Steir's action paintings keep us firmly in the moment of looking. Nature is rendered simply by a substance that mimics the subject itself; a watery tautology. Known loosely as "process based work," the materials that the artist uses speak for themselves, so the work exists by virtue of the method employed. Steir is technically expert at coaxing thin rivulets of paint to coalesce and merge into deliquescent layers that converge to simulate real-life cascades. Her method is a mixture of happenstance and control.

Steir first meditates, then takes a leap into her work like a gymnast, confirming the physicality of the process. Like Pollock, she relies on repeated choreographed actions, but her canvas is on the wall as she works, rather than the floor, and she uses only oil and turpentine.

Steir's skeins of diluted paint collapse in natural gravitational rhythms that echo the mountain waterfall or the urban fountain jet. Here, her subdued palette recalls Whistler's somber views of the Thames, but despite its ancient mode of production, it is very much of today. What might seem to be a haphazard confusion is actually a highly choreographed ballet of dried paint, caught at the moment of impact and recorded as the thin translucent veils leave their descending marks.

Here we have an example of a painting that operates synchronously as a landscape and as an abstraction; it could also be discussed as a portrait of a waterfall.

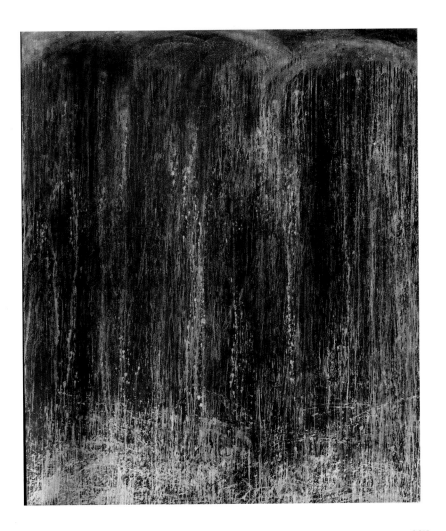

Grey Space (Distractor)

Artist
Julie Mehretu

Date *2006*

Medium & Support
*acrylic and ink
on canvas*

Measurements
*72 x 96 in.
(182.9 x 243.8 cm)*

Location
St Louis Art Museum

▶ **Collision**
The eye wanders over
the surface and it hovers
at points where lines
converge and morph
into other shapes,
thicknesses, and colors,
then swiftly moves on,
attempting to decipher
the maelstrom of bursts
and swirls floating on
and in the matte pale
"Grey Space."

This work, like its title, feels spacey, a kind of cosmic unfurling of Suprematist arrows conscripted into a contemporary music of the spheres. The fluorescent pink, yellow, and red add a zest and enhance the three-dimensional effect of the swirling mass of line, color, and shape. This work feels intensely active, but the conflict is suspended, as if the director has called "Cut!" and we are experiencing the final frame of a film.

A network of black and white calligraphic lines of different thicknesses crisscrosses the shifting viewpoint, turning the picture plane into a carousel of blinking color. A formation of black stars emerges in a flight pattern to the right hand, ducking under the range of competing areas of bright yellow. The strata of the painting are formed by layers of both acrylic and ink.

Technically Mehretu often works over a large area, mixing a number of interconnected ways of working, including projection, tracing, mixing visual metaphors, and architectural drawing. The overall aim is to give an equal weight to the individual parts so when viewed close up, they retain their own integrity, yet from a distance regain a bond with the overall concept of the entire piece. *Grey Space* has a microcosmic-macrocosmic relationship pattern, similar to viewing a city at night as a plane approaches land, yet still being able to recognize certain landmarks.

"*I began to look at my
mark-making lexicon as
signifiers of social agency,
as individual characters.*"

**INTERVIEW WITH
OLUKEMI ILESANMI, 2003**

Appendices

Glossary

ACRYLIC,
plastic (synthetic) water-based paint.

ALLA PRIMA/WET-ON-WET,
of oil paint, working wet paint into wet, without allowing the layers to dry between coats.

ALLEGORY,
a story with a hidden symbolic meaning.

APOTHEOSIS,
the act of rising heavenward, often depicted in religious art.

ART BRUT (LITERALLY, "RAW ART"),
term for a type of art outside the fine art tradition. Originally coined by Dubuffet for work created by untrained, often troubled artists.

BALANCE,
often used in relation to composition, describing whether the elements of a picture are equally weighted.

BRAVURA,
brushstrokes that combine confidence with an element of vanity and display.

BRUSHES,
made from different types of hair or nylon bound by metal ferrules onto wooden or plastic stick holders to apply paint.

CANVAS,
material, often cotton or linen, used as a surface for painting.

CHARCOAL,
burnt willow twigs used to make outlines in the early stages of painting design.

CHIAROSCURO,
describes the effect of intense light and dark used for dramatic effect within a painting.

CLOTH OF HONOR,
a hanging, decorated cloth often found behind the Virgin in Renaissance painting.

COLLAGE,
term to describe an artwork that uses a selection of materials stuck together. In 3D this is known as an assemblage.

COMPLEMENTARY COLORS,
relating to color theory, these are color pairings that are opposite each other in the color wheel: red>green (mixture of blue and yellow), blue>orange (red and yellow), yellow>purple (blue and red).

CONTRAST,
when two opposite colors come together to jarring effect.

COTTON DUCK,
basic cotton canvas.

CROSSHATCHING,
making close parallel lines and overlaying them at an angle to produce a darker shade.

DI SOTTO IN SU,
the Italian for "from below to above"; used on high surfaces or ceilings to give the illusion that a figure is suspended in the air above the viewer.

DUOCHROME/TONE,
two contrasting colors.

FÊTES CHAMPÊTRES,
literally "outside festivities," as frequently depicted by artists such as Watteau.

FILIBERT,
long, thin brush suitable for controlled sweeps of paint or for painting text and numerals.

GENRE PAINTING,
descriptive of everyday scenes depicting ordinary people as the subject matter for painting, particularly used in 17th-century Holland.

GESSO,
chalk and glue (plaster) suspension, producing a hard, white, porous painting surface. Ideal for rendering bright, pure color.

GLAZE,
colored layer of pigment suspended in medium that forms a transparent colored layer, through which the eye can discern tint and tone.

GOUACHE,
water-based paints with body added, making them thick and opaque.

GRISAILLE,
name given to a painting done in tones of gray, often a preparatory work.

GROUND,
the first painted layer on which the painting is then created. Can be any color, but often a gray mid-tone.

GUM ARABIC,
natural glue excreted from
the acacia tree.

HARMONY,
when two or more colors, often
close together in the spectrum,
come together to create a
pleasing effect on the eye.

HOG HAIR BRUSH,
stiff brush used for broad areas
of paint application.

HUE,
term applied to a particular
color sensation. Staring at a
saturated hue will leave its
complementary colored image
on the retina.

IMPASTO,
thickly painted.

LABELS,
fixed by dealers to the reverse
of paintings where they can
sometimes help with defining,
confirming, or even confusing
provenance.

LINEN,
material functioning as canvas
support, made from woven flax.

LINSEED OIL,
a drying oil used as a paint
medium.

MAHL STICK,
stick with one end covered
in a soft ball of fabric; used,
balanced on the edge of the
canvas, to allow the artist to
lean over wet paint and work
further without smudging.

MEMENTO MORI,
work that reminds the audience
of its mortality.

MID GROUND,
a base color, like skin-tone,
often a warm gray.

MINERAL SPIRITS,
thinner for oil paint also
used to clean brushes.

MONOCHROME,
of one color only; an artist
can make tints (light) or tones
(dark) from this original color.

OIL PAINT,
ground pigment suspended in
oil to use as paint.

OPAQUE,
lacking transparency, incapable
of being seen through.

ORIGINAL,
first, only authored image
or painting.

PANEL,
wooden or metal surface on
which to paint.

PENTIMENTO/I,
visual trace/s of previous layer/s
of paint that indicate when an
artist has changed his or her
mind about the form of
something on the canvas.

PERSONIFICATION,
something taking on another
aspect in order to reveal its
true nature.

PERSPECTIVE,
the mathematical way to
suggest that a foreground,
middleground, and background
exist within a work, with a
vanishing point toward which
the eye is directed.

PIGMENTS,
ground colors added to a
medium to form paint.

PLEIN AIR,
refers to painting outside. The
Impressionists followed the lead
of the Barbizon artists, becoming
close to nature in this way.

POINTILLISM,
independent dotted brushmarks
that, when laid down adjacent
to one another, allow colors to
mix optically.

POLYCHROME,
many-colored. Often used in
relation to painted sculpture.

PRIMER,
preparatory layer of paint
applied to a painting surface.

PROPORTION,
the relative scale of one thing
to another, hence "correct
proportion" and "out of
proportion."

PROVENANCE,
literally where the painting
comes from—who made it and
where; who then bought it, kept
it, or sold it.

PUTTO/PUTTI,
angels that populate invented
compositions.

QUIRE,
old-fashioned paper quantity
equivalent to 25 sheets of the
same size and quality.

SABLE BRUSHES,
usually thin brushes made from
sable (a mink-like rodent), used
for detailed and delicate work.

Glossary

SALON-STYLE,
paintings hung so they cover entire walls from floor to ceiling.

SCUMBLE,
an atmospheric effect created by covering one layer of paint with another thin, opaque or semi-opaque, layer.

SFUMATO,
from the Italian *fumo*, meaning "smoke." This describes a blending technique that merges oil paint, creating a fuzzy, undefined border to two areas of a painting.

SHADE,
a darker tone, often of the color alongside it.

SIZE,
granules of rabbit-skin glue dissolved in hot water and painted onto raw canvas or linen as a first surface. When dry, it renders the canvas taut and even. Can be sanded down for extra smoothness before a second coat is applied.

SKIN TONE,
often a basic mid-tone (for example a light gray or pale beige) that can accommodate highlights, color, and shadow.

STIPPLE,
a repetitive mark made by dabbing a stiff brush end at right angles to the surface of the work, creating a spotty effect.

STRETCHER,
the frame over which a canvas is pulled and fixed to create a painting surface.

STUCCO,
material made from cement, sand, and water, with fibers added to increase density.

SUPPORT,
the surface of a painting that can be the panel or the stretcher.

SYMMETRY,
something made up of exactly similar parts facing each other on either side of a central line or around a point or axis.

TABLE,
15th-century term for a solid wood painting panel.

TEMPERA,
paint created by using egg yolk as pigment binder.

TINT,
on the lighter side of the spectrum, using white to lighten the color making a tint.

TONE,
a darker value or part of a color.

TRANSLUCENT,
capable of transmitting light but not detailed shapes or objects.

TRANSPARENT,
clear; capable of transmitting light.

TROMPE L'OEIL,
literally "trick the eye"; used to describe works such as the painting by Gysbrechts (*see p12*).

TURPENTINE,
thinner or solvent for oil paint, distilled from mainly pine-tree resin.

VANITAS,
a collection of objects, rendered in paint, that focus on the luxuries of human life. Such a collection might include silver vessels, books, and letters, as well as fruit and flowers.

VARNISH,
a final protective resin coat laid onto a completed, dried painting that seals it and adds extra depth, color, and dimension.

VIGNETTE,
a smaller illustrative work, often with shaded borders, that sits inside another larger one.

WATERCOLOR,
transparent paint created by using gum arabic as pigment binder. Water is used to dissolve and disperse it.

Resources

Books

Dates refer to the most recent edition at the time of this publication.

Art & Illusion
Ernst H. Gombrich
(Phaidon Press, 2002)

Hall's Dictionary of Subjects and Symbols in Art
James Hall
(John Murray, 1989)

How to Read a Modern Painting: Lessons from the Modern Masters
Jon Thompson
(Thames & Hudson, 2007)

The Materials and Techniques of Painting
Jonathan Stephenson
(Thames & Hudson, 1993)

Meaning in the Visual Arts
Erwin Panofsky
(University of Chicago Press, 1983)

The Shock of the New
Robert Hughes
(Thames & Hudson, 1991)

The Story of Art
Ernst H. Gombrich
(Phaidon Press, 1995)

The Story of Modern Art
Norbert Lynton
(Phaidon Press, 1994)

This is Modern Art
Matthew Collings
(Seven Dials, 2000)

Ways of Seeing
John Berger
(Penguin Classics, 2008)

The Work of Art in the Age of Mechanical Reproduction
Walter Benjamin
(Penguin, 2008)

Web sites

BBC Your Paintings in partnership with the *Public Catalogue Foundation*
www.bbc.co.uk/arts/yourpaintings/

CAMEO: Conservation & Art Materials Encyclopedia Online
cameo.mfa.org

Getty Google ART project
www.google.com/culturalinstitute/project/art-project

Grove Art Online
www.oxfordartonline.com/public/book/oao_gao
Grove Art Online is the foremost scholarly art encyclopedia, covering both Western and non-Western art. First published as the landmark 34-volume *Dictionary of Art*, edited by Jane Turner, the content of Grove Art encompasses all aspects of visual culture.

Directory of Paintings

Directory of Paintings

Directory of Galleries

ALBRIGHT-KNOX ART GALLERY
1285 Elmwood Avenue
Buffalo, New York, 14222-1096
USA
www.albrightknox.org

ALTE PINAKOTHEK
Barer Straße 27
80333 Munich
Germany
www.pinakothek.de

ART GALLERY OF ONTARIO
317 Dundas Street West
Toronto, Ontario, M5T 1G4
Canada
www.ago.net

ART INSTITUTE OF CHICAGO
111 S. Michigan Avenue
Chicago, Illinois, 60603
USA
www.artic.edu

ASHMOLEAN MUSEUM
Beaumont Street
Oxford, OX1 2PH
England
www.ashmolean.org

BROOKLYN MUSEUM OF ART
200 Eastern Parkway
Brooklyn, New York, 11238-6052
USA
www.brooklynmuseum.org

THE CLEVELAND MUSEUM OF ART
11150 East Boulevard
Cleveland, Ohio, 44106
USA
www.clevelandart.org

**CORCORAN GALLERY OF ART
CORCORAN COLLEGE OF ART &
DESIGN**
500 Seventeenth Street NW
Washington, DC, 20006
USA
www.corcoran.org

CULTURAL CENTRE OF BELÉM
Praça do Império
1449-003 Lisbon
Portugal
www.ccb.pt

FERENS ART GALLERY
Hull City Council
Queen Victoria Square
Hull, HU1 3RA
England
www.hullcc.gov.uk/ferens

FITZWILLIAM MUSEUM
Trumpington Street,
Cambridge, CB2 1RB
England
www.fitzmuseum.cam.ac.uk

**FREER GALLERY OF ART,
SMITHSONIAN INSTITUTION**
1050 Independence Ave SW
Washington, DC, 20013-7012
USA
www.asia.si.edu

FRICK COLLECTION
1 East 70th Street
New York, New York, 10021
USA
www.frick.org

GEMEENTEMUSEUM DEN HAAG
Stadhouderslaan 41
2517 HV, The Hague
Netherlands
www.gemeentemuseum.nl

GUGGENHEIM MUSEUM
1071 Fifth Avenue
New York, New York, 10128
USA
guggenheim.org

HATFIELD HOUSE
Great North Road
Hatfield, Hertfordshire, AL9 5NQ
England
www.hatfield-house.co.uk

HERMITAGE MUSEUM
Dvortsovaya Naberezhnaya, 34
190000 St Petersburg
Russia
www.hermitagemuseum.org

J. PAUL GETTY MUSEUM
1200 Getty Center Drive
Los Angeles, California, 90049-1687
USA
www.getty.edu

KENWOOD HOUSE
Hampstead Lane
Hampstead, NW3 7JR
England
www.english-heritage.org.uk

KUNSTHALLE BREMEN
Am Wall 207
28195 Bremen
Germany
www.kunsthalle-bremen.de

HAMBURGER KUNSTHALLE
Glockengießerwall
20095 Hamburg
Germany
www.hamburger-kunsthalle.de

LEEDS ART GALLERY
The Headrow
Leeds, LS1 3AA
England
www.leeds.gov.uk

**METROPOLITAN MUSEUM
OF ART**
1000 Fifth Avenue
New York, New York, 10028-0198
USA
www.metmuseum.org

MINNEAPOLIS INSTITUTE OF ARTS
2400 Third Avenue South
Minneapolis, Minnesota, 55404
USA
new.artsmia.org

MUSÉE DE L'ORANGÉRIE
Jardin des Tuileries
75001 Paris
France
www.musee-orangerie.fr

MUSÉE DU LOUVRE
75058 Paris
France
www.louvre.fr

MUSÉE D'ORSAY
62, Rue de Lille
75343 Paris Cedex 07
France
www.musee-orsay.fr

MUSÉE MATISSE
Palais Fénélon, Place du
Commandant-Richez
59360 Le Cateau-Cambrésis
France
museematisse.lenord.fr

MUSÉE NATIONAL D'ART MODERNE
11 Avenue du Président Wilson
75116 Paris
France
www.mam.paris.fr

MUSÉE PICASSO PARIS
Hôtel Salé
5 Rue de Thorigny
75003 Paris
France
www.museepicassoparis.fr

MUSEUM OF FINE ARTS, BOSTON
465 Huntington Avenue
Boston, Massachusetts 02115
USA
www.mfa.org

MUSEUM OF MODERN ART
11 West 53 Street,
New York, New York, 10019
USA
www.moma.org

NATIONAL GALLERY
Trafalgar Square
London, WC2N 5DN
England
www.nationalgallery.org.uk

NATIONAL GALLERY OF ART
6th Street and Constitution Avenue
NW
Washington, DC, 20565
USA
www.nga.gov

NATIONAL GALLERY OF AUSTRALIA
Parkes Place, Parkes
Canberra, Australian Capital
Territory, 2600
Australia
www.nga.gov.au

NATIONAL GALLERY OF VICTORIA
180 St Kilda Road
Melbourne, Victoria, 3006
Australia
www.ngv.vic.gov.au

NATIONAL GALLERY OF NORWAY
Universitetsgata 13
0164 Oslo
Norway
www.nasjonalmuseet.no

**NATIONAL MUSEUM OF WOMEN
IN THE ARTS**
1250 New York Avenue NW
Washington, DC, 20005
USA
www.nmwa.org

NATIONAL PORTRAIT GALLERY
St Martin's Place
London, WC2H 0HE
England
www.npg.org.uk

NELSON-ATKINS MUSEUM OF ART
4525 Oak Street
Kansas City, Missouri, 64111
USA
www.nelson-atkins.org

NEUE GALERIE
1048 Fifth Avenue
New York, New York, 10028
USA
www.neuegalerie.org

PENNSYLVANIA ART ACADEMY
118 N Broad Street
Philadelphia, Pennsylvania, 19102
USA
www.pafa.org

Directory of Galleries

THE PHILLIPS COLLECTION
1600 21st Street, NW
Washington, DC, 20009
USA
www.phillipscollection.org

PINACOTECA DI BRERA
Via Brera, 28
20121 Milan
Italy
www.brera.benicultural.it

PRADO MUSEUM
Calle Ruiz de Alarcón 23
Madrid 28014
Spain
www.museodelprado.es

ROYAL ACADEMY OF ARTS
Burlington House, Piccadilly
London, W1J 0BD
England
www.royalacademy.org.uk

ROYAL MUSEUM OF FINE ARTS
Lange Kievitstraat 111-113 bus
100,
B-2018 Antwerp
Belgium
www.kmska.be

ST LOUIS ART MUSEUM
1 Fine Arts Drive
St Louis, Missouri, 63110
USA
www.slam.org

**SAN FRANCISCO MUSEUM
OF MODERN ART**
151 3rd Street
San Francisco, California, 94103
USA
www.sfmoma.org

SANTA MARIA DEL POPOLO
Piazza del Popolo, 12
00187 Rome
Italy
www.santamariadelpopolo.it

**SMITHSONIAN AMERICAN ART
MUSEUM**
8th and F NW,
Washington, DC, 20004
USA
www.americanart.si.edu

TATE MODERN
Bankside
London SE1 9TG
England
www.tate.org.uk

THE BROAD ART FOUNDATION
3355 Barnard Way
Santa Monica, California, 90405
USA
broadartfoundation.org

TRETYAKOV GALLERY
Lavrushinskiy Pereulok, 10,
Moscow, 119017
Russia
www.tretyakovgallery.ru

VAN GOGH MUSEUM
Paulus Potterstraat 7,
1071 CX Amsterdam
Netherlands
www.vangoghmuseum.nl

WADSWORTH ATHENEUM
600 Main Street
Hartford, Connecticut, 06103
USA
www.thewadsworth.org

WALKER ART GALLERY
William Brown Street
Liverpool, L3 8EL
England
www.liverpoolmuseums.org.uk/
walker

WALLACE COLLECTION
Hertford House, Manchester Square
London, W1U 3BN
England
www.wallacecollection.org

WALLRAF-RICHARTZ MUSEUM
Obenmarspforten
50667 Cologne
Germany
www.wallraf.museum

**WHITNEY MUSEUM OF AMERICAN
ART**
945 Madison Avenue
New York, New York, 10021
USA
whitney.org

Index

Index

Acknowledgments

Author acknowledgments

I have tried my best to readjust the balance of often underrepresented categories of artist, but in a small book with a large remit, and the whole of an art historical canon to contend with, my desire has been tricky to accommodate.

I would like to thank all who have helped and inspired me, too many to name individually. In particular I thank colleagues at the Slade School of Fine Art and The National Portrait Gallery and also Ron Bowen, Peter Brawne, Philippa Farrant, Bénédicte Genet, Sophie Gibson, Michael Helston, Klaas Hoek, Larry Keith, Graham Law, Jock McFadyen, Sandy Nairne, Eileen Powell, Marie Louise Sauerberg.

Research for this book was supported by The Slade School of Fine Art, UCL and the Art Fund through the Jonathan Ruffer Curatorial Grants programme.